Manual of Lithography

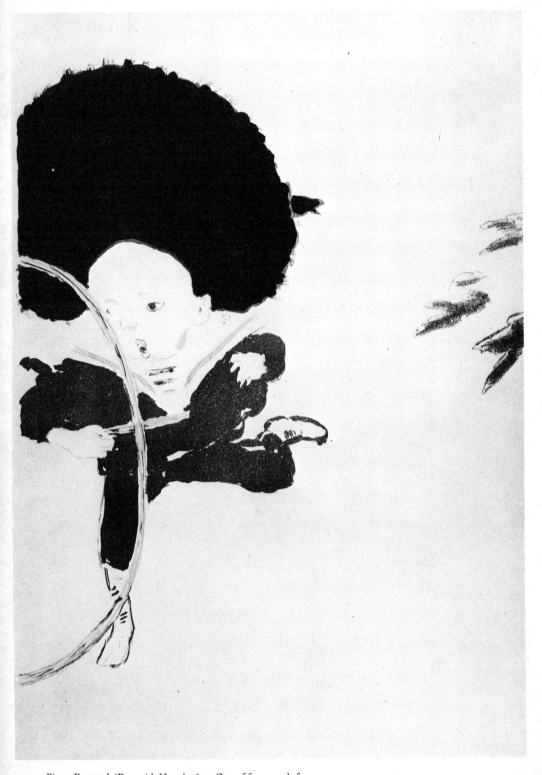

Pierre Bonnard, 'Boy with Hoop', 1897. One of four panels for a screen.

Richard Vicary

Manual of
Lithography

Charles Scribner's Sons
New York

1 3 7 9 11 13 15 17 19 I/C 20 18 16 14 12 10 8 6 4 2

Printed in Great Britain
Library of Congress Catalog Card Number 76–9656
ISBN 0–684–14748–3

Contents

Acknowledgements

Firstly, I would like to thank all the artists who have generously given permission for their lithographs to be reproduced.

I am also indebted to the following persons, schools, print workshops and galleries for their patient and willing co-operation in supplying research information, illustrations or facilities for photographing: the Trustees of the British Museum and of the Victoria and Albert Museum; the Principals and staffs of Camberwell School of Art and Crafts, London, Newport College of Art and Design, and Shrewsbury School of Art; Akademie der Künste (Käthe Kollwitz Archiv), Berlin; Courtauld Institute, London; Rosemary Simmons of Curwen Prints Ltd, Stanley Jones, Bert Wootten and the staff of the Curwen Studio; Pat Gilmour of the Print Department, the Tate Gallery, London; Barbara Lloyd of Marlborough Graphics, London; Oslo Kommunes Kunstsamlinger, Munch-Museet; N. J. Parry Esq.; Mrs Frances Richards; J. F. Schreiber Verlag and Roland Offset, Offenbach am Main; Andrew Stasik, Director of the Pratt Graphics Center, New York.

. Furthermore, I record my appreciation for their help with technical matters to the Forrest Printing Ink Company, London; Jack Maisey of the Rubber and Plastics Research Association; John Millard of W. S. Cowell Ltd, Ipswich.

Finally, I owe a special debt of gratitude to Gerald Woods for the photographs of craft processes, and his valued assistance in other matters too numerous to record.

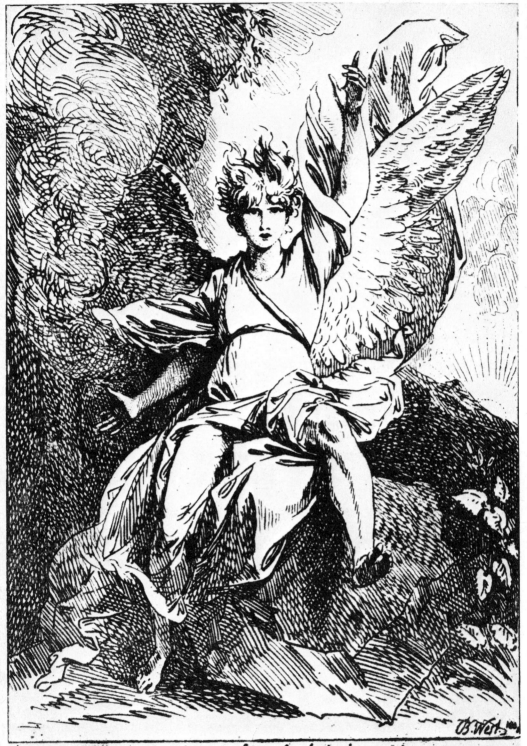

He is not here: for he is risen. &c.

Benjamin West, 'He is not here, for he is risen'. From *Specimens of Polyautography*, 1803.

Introduction

In Britain before 1939, lithography was regarded as a some-what esoteric craft, and this feeling is echoed in several of the books on lithographic printmaking which were published between the wars. It was also known as 'the painter's craft', probably because of the opportunities which it afforded for direct draughtsmanship, rather than its capacity for colour printing. Except for the few artists who were sufficiently interested to experiment with the medium, colour litho-graphy was not enthusiastically embraced by the painter.

Although lithography is still practised as an adjunct to painting and sculpture, and has made many advances because of this association, it has now taken its place as a primary means of expression on the same level as the fine arts. 'Printmaker' is a new word in our vocabulary, and sums up the artist's total commitment to this young pro-fession. Therefore, in the main, I have attempted to discuss lithography at this level, and also in the context of other influences which, for historical or practical reasons, have played a part in its development.

Where it appears necessary, the craft is displayed against the background of its more lowly and often condemned sister, chromolithography, as it seems likely that, had not this type of work been developed and perfected by printers during the nineteenth century, the colour experiments of Chéret and, later, Toulouse-Lautrec could not have taken place at so early a period.

It is sometimes argued that it is not vitally necessary for the lithographer to understand the scientific basis of his craft in order to make successful prints, but the introduction of sophisticated techniques, particularly during the past decade, makes such knowledge essential if his experiments are to carry authority and the frontiers of his operations are to be extended.

In many fields, including dyeing, tanning and painting – all, incidentally, possessing common ground with litho-graphy – the knowledge has been gained by craftsmen using close empirical observation over many years without fully understanding the scientific implications of their work. It is only comparatively recently that this knowledge has been confirmed by controlled research. In spite of this, there is still considerable divergence in the explanations offered by different authorities for the various chemical and physical actions of the materials used in the craft, particularly

with regard to the underlying natural phenomena which make the craft possible, and etching procedures.

The craft processes described are basic, and as far as possible involve the use of chemicals and solutions which are readily available from the chemist and easily made up in the studio. They are cheaper than the equivalent proprietary brand, but when a proprietary solution must be used, this has been clearly indicated.

Lithography has gone through a cycle of craft development which is not uncommon, and one that is shared by the other printing processes, more particularly typography. In its infancy, it was the preserve of the artist–designer, the equivalent of the early scholar–printers. Later, during its adoption for industrial and reproductive purposes, and generally at the expense of artistic standards, it achieved its major technical advances. Of these, the technique which, later, was much used by artists was colour printing. Stipple, another popular nineteenth-century commercial technique, was never fully embraced by the creative lithographer.

The history of the craft can be separated into two or three distinct periods. In common with the other arts, lithography, during its history, has been given impetus and direction by a small number of artists who have possessed the ability to sum up all that had been previously accomplished, while at the same time laying down paths for its future development. Of these, the two most influential have probably been Toulouse-Lautrec and Picasso. The former elevated colour printing to a creative rather than a reproductive art, while the latter, uninhibited by accepted craft disciplines, extended the range of autographic image-making techniques. Prior to his work in the medium, all auto-lithographed images had been made in traditional methods, using gum, chalk and ink, any variation occurring only in the means of application. This gave to the work the characteristic atmospheric and chalky quality that had always been associated with this type of print. The thin washes that were occasionally used were generally limited to those obtainable on stones, following the example of Whistler. The washes used in many contemporary prints are more positive and granular in texture, and are more durable as printing images. These washes are post-war innovations and probably originate from Picasso's work in the medium.

Picasso's ability to see a medium in its totality also led him to experiment with transfer papers so that they could make a uniquely positive contribution to the quality of the final image. Hitherto, their use had been mainly passive, and consisted of the mechanical transfer of images from plate to plate or of a complete drawing down to the plate.

Among more recent discoveries are the use of photography, the mixed-media print in which lithography is combined with relief, intaglio or screen-printing methods, and the incursion of lithography into the field of three-

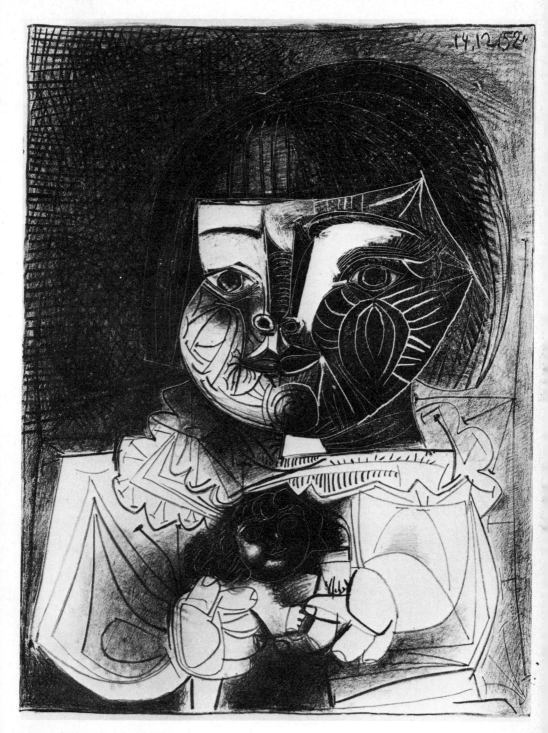

Picasso, 'Paloma et sa Poupée', December 1952.

dimensional work, which may have its origins in the old chromolithographed cut-out books for children, Pollock's 'penny plain, twopence coloured' model theatre sheets, or commodity display and packaging.

Thus, with this array of alternative techniques confronting the printmaker, it is no wonder that compared with the past, contemporary lithography is characterized by a rich diversity of approach.

Therefore, both the history of the craft and the descriptions of the processes may be roughly divided into pre-Picasso and post-Picasso. This book deals mainly with developments before the nineteen-fifties; more recent material will be covered in a later volume.[1] That there should be a degree of overlap is inevitable. Traditional techniques are still widely employed, and some of the examples shown may not strictly conform to this arbitrary time division.

In comparison with the nineteenth century, the twentieth has been a period of accelerating and violent change; it is inevitable that the qualities of cynicism, nostalgia and protest are frequently displayed in the work of the printmaker. Thus, in the next volume there is an emphasis on contemporary work and prints produced since the war. As far as possible, these have been chosen to demonstrate the breadth of subject-matter as well as new techniques.

The work of many lithographers in France and Germany produced during the past century and a half is well known, and widely dispersed in museums and galleries. It will be found that examples by these artists have been omitted in order to make room for prints by less well-known lithographers, so that while some printmakers who are mentioned in the text may not be represented by illustrations of their work, the reverse also holds true.

Also, as the work proceeded, there was an unexpected proliferation of material, and it became a question not so much of what to include, but of which material to discard.

The bibliography (p. 137) has been compiled with the aim of encouraging research by the serious student, though it cannot in any way be considered exhaustive. By present-day standards, some earlier books on the craft are rather limited and only possess historical interest. Some of the manuals produced before 1940 concentrate mainly on stone and monochrome work, with little advice about working on plates, or colour printing. This lack is rather surprising in view of the work of Bonnard and Vuillard at the turn of the century, though it may be explained by the general lack of interest shown by British artists of the period.

Pennell, while alive to the possibilities displayed by Japanese woodcuts, and even advocating making colour lithographs in their style, does not fully develop the subject in the 1915 edition of his book.

[1] *The Manual of Advanced Lithography.*

From the purely craft aspect, David Cumming's *A Handbook of Lithography*, published in 1904, but especially the 1949 edition, must be considered an exception. He is revealed as a man who loved his craft; this book is for the journeyman printer and makes no higher pretensions.

The books written since the war reflect the improved status of lithography and avoid the rather esoteric quality of some of their predecessors by approaching the subject in a much more professional manner.

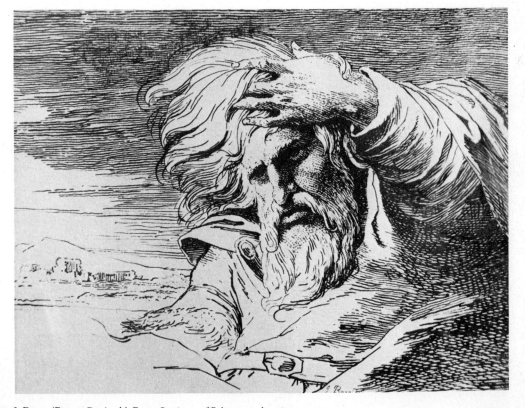

J. Barry, 'Eastern Patriarch'. From *Specimens of Polyautography*, 1803.

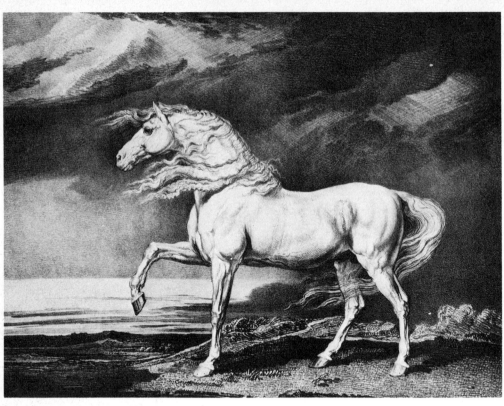

James Ward, 'Adonis', 1824.

Géricault, untitled lithograph. One of a series of studies of horses for the firm of Gihaut, *c.* 1822.

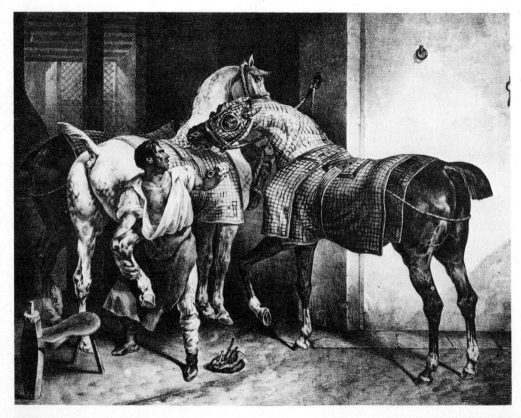

1 Historical survey

In his book, *A Complete Course of Lithography* (1819), Alois Senefelder describes the long period of experiment which led to the discovery of what is now the major form of planographic printing, so the early development of the craft is well documented. Senefelder had aspirations as a composer and playwright, but fortunately for posterity and the graphic arts these were not shared by the publishers of the time. He therefore set to work to devise a means of printing his own music and writing, by etching slabs of the locally quarried limestone in relief, and printing from them. (The fact that he was living near to the world's only source of the limestone most suited to the process can be regarded as fortuitous.) He tells us that after several thousand experiments he realized that relief-etching the stone with the gum arabic and nitric acid solution which he was using was unnecessary. He found that merely their application was sufficient to transform the quality of the background, so that in its damp state it would repel the printing ink, and that the soap and tallow mixture with which he was drawing his images altered the character of the stone on which it had been applied, and made it repel water.

Partially washed-out zinc plate, showing the wet non-printing areas and the greasy image areas.

Having established the keystone of the process, namely the affinity which certain fats have for limestone – what we now call 'adsorption' – after further experiment he was able to present the complete method to the public in 1798.

Continuing with his experiments over the next decade or so, he developed transfer papers and extended the principles to printing from zinc plates. He also devised a new form of press which could print the stones with a scraping motion, and introduced the technique of inking by roller instead of the leather dabber which at the time was the normal method of inking type and relief blocks. The first rollers for this type of printing appeared about 1810. Thus, within the limitations of the technical knowledge available to him, he envisaged most of developments which his method promised.

Senefelder was quick to realize that his was the only printing method in which chalk texture could be achieved, and he also saw the advantages accruing from the use of transfer paper: it was ideal for work away from the printing shop, as well as rendering unnecessary the reversing of the image on to the stone, for this would be done automatically during the transferring process. He regarded his 'chemical

printing' as a method which possessed much greater flexibility than either relief or intaglio methods.

In view of his lack of business acumen, it was fortunate that he entered into partnership with Joachim André, a publisher from Offenbach am Main, for the commercial exploitation of the invention. Accompanied by Phillip, Joachim's brother, Senefelder travelled to London and set up in business. Stones were sent to eminent artists together with instructions for working them, and these were returned to London for processing and printing. The result of this activity was a portfolio of prints published in 1803 as *Examples of Polyautography*. These are not the earliest prints in the medium, as some which were made in Germany pre-date them by two years, but this set must be regarded as the first published collection of artists' lithographs. The contributors to this portfolio included Thomas Stothard, Henry Fuseli, Richard Cooper and the American expatriate painter Benjamin West. These earliest lithographs were conceived by the artists in terms of etching; in other words, they were strongly linear. It must be remembered that etching with tones by aquatint had only recently been introduced into England, and that mezzotints were almost exclusively used as a reproductive medium.

During this period of 'incunabula', which is generally accepted as lasting from 1800 to 1819, other British artists working on the stone were John and Cornelius Varley, Samuel Prout, John Sell Cotman and H. B. Chalon, who is credited with making the first successful chalk-drawn lithograph. Chalk, because of its capacity for making emotional and atmospheric tonal images, is a method more suited to the romantic approach, and it was not long before artists were beginning to discover this specialized language of lithography. By 1810, most artists using the craft had embraced the chalk manner and were commencing to exploit some of the range of tone and texture latent in the medium. By 1820, the romantic concept was well established, and was fully realized in Charlet's prints of Napoleon's *Grande Armée* and also in the work of Géricault.

In a sense, a study of the early development of lithography is a study both of the Industrial Revolution and of the Romantic movement. The first litho presses used by Senefelder and the early lithographers were made from wood, and models of this type are still in use on the Continent. In fact, until 1800, wood was the main material used in the construction of all presses, and their design had remained virtually the same as the modified wine press which Gutenberg had used in the fifteenth century. However, the period between 1800 and 1820 witnessed a remarkable change in this state of affairs as the first cast-iron platen presses for printing type were introduced, to be closely followed by König's invention of the steam-driven cylinder press, two of which were installed at *The Times* in 1814. The first

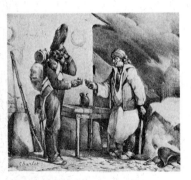

Charlet, 'Aux vieux grognards! Le tailleux de pierre reconnaissant', *c*. 1830.

'The Express Galop': Victorian lithographed music cover.

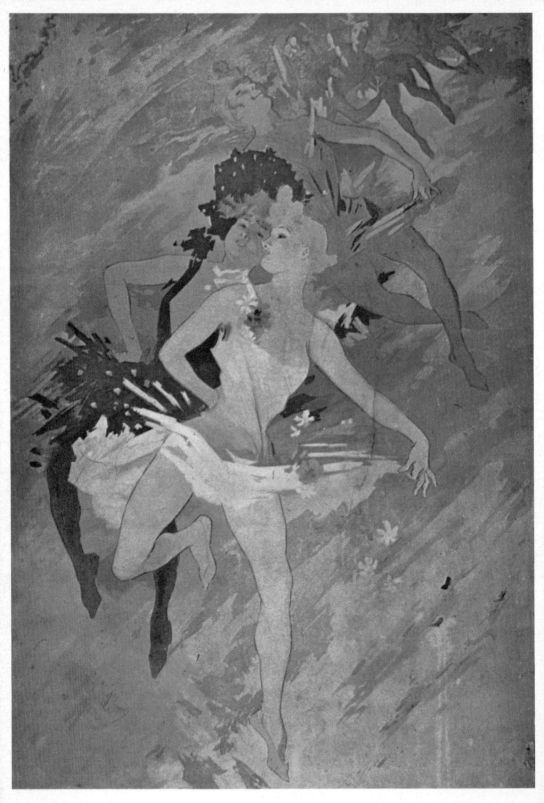

Chéret, poster without text, *c.* 1870. The background is surprisingly
spontaneous in the freedom of its drawing and in the use of overprinting.

powered litho presses were introduced in Paris in 1833, the year before Senefelder's death, and their use was established in Europe well before the first one in Britain became operative in 1852.

It can be seen that Senefelder's life overlaps those of all the major romantic figures in the arts of the period, including Beethoven, Byron, Shelley and Goethe, so it might be argued that the ultimate destiny of lithography to be a mainly romantic medium was a probability, emerging as it did in an age of technological invention and idealism. Although the Industrial Revolution was young, its impact on the graphic arts was marked. Communication via the printed word was developing sufficiently rapidly to warrant the introduction of daily newspapers. Typographic posters, now so cherished by collectors, were also being printed. Also, the basic chemistry of photography was known and only awaiting the catalysing activities of Nièpce, Daguerre and Fox Talbot.

R. J. Lane, 'A girl at her devotions', 1826.

After the initial interest in the new method, apart from one or two artists, British enthusiasm waned. Blake and Thomas Bewick each made one print in the medium, but the two dominant painters of the period, Turner and Constable, displayed no interest in it. The craft was saved from complete extinction by the energies of Hullmandel, an ex-pupil of Senefelder, who had settled in London and, together with Rudolph Ackermann, whose 'Repository of the Arts' was a thriving print-selling and publishing house during the early eighteen-hundreds, produced a number of portfolios of lithographs. These were mainly prints illustrating romantic journeys in Egypt, the Holy Land and Europe. Among the contributing artists were Prout, Harding, James Ward and Cotman, who was exploiting the 'Lithotint', a technique envisaged by Senefelder and suggested to Cotman by Hullmandel, himself a competent performer on the stone. This technique involves the use of two stones, one which prints in a pale neutral colour from which the highlights have been scraped, and one which then overprints the main drawing in a dark colour, usually black. Cotman used this method for a series of landscapes and interiors, and sometimes used a third stone to heighten his effects.

Louis Haghe, 'From the Holy Land', 1843.

One of the reasons for the decline of the craft in Britain was the heavy tax which the government had put on imported litho stones – an official art policy which echoed the punitive tax on British typefounders two centuries earlier which had successfully delayed the advent of a major British type designer until the eighteenth century, in the person of William Caslon.

This generally disappointing picture was not echoed in France, where the medium was introduced by Frederic André, brother to Joachim and Phillip, in 1803. After a slow start, during which time the craft was investigated by the Director of Museums, official backing and encouragement was given by the government in 1809 for the establishment

Engelmann, 'Maîtresse d'auberge à Winkel'. Hand-coloured lithograph.

Le Comte de Lasteyrie, 'L'un soutient l'autre'. Hand-coloured lithograph.

of presses; by 1816, there were several thriving lithographic workshops in the country, and by 1830 there were lithographers working in most French towns.

Engelmann, another pupil of Senefelder, set up a press in Paris in 1818. Of all early lithographers, he was one of the most influential, as it was through his direct or indirect persuasion that many eminent artists began to practise the craft. He published two books on lithography and is credited with having coined the name and invented the process of chromolithography, although this is disputed by some authorities.

Lithography was also regarded as an educational pastime for wealthy dilettantes, and at least two studios, those of le Comte de Lasteyrie and Vivant Denon, were founded to cater for this demand.

Géricault and Delacroix both lithographed prolifically, using the chalk manner, while Goya, aged seventy-nine and exiled in Bordeaux, made twenty-three prints in the medium. The scintillating quality of these chalk drawings is in striking contrast to the more heavily dramatic images of the two French artists.

Lithography was also invading the preserves of etching and engraving as a means of illustrating the portfolios and books on travel which were so popular at this time, though for more serious illustration its impact was less. It was considered that lithographed illustration was incapable of properly integrating with the printed word, so for illustrated literary work the established processes of intaglio and relief methods were preferred. Because of this, lithographs took the form of inserts or loose leaves, so that the publications gave more the appearance of albums. It is interesting to note, in relation to this point, that during the mid-century period, both Daumier and Gavarni abandoned the stone and used the woodblock for book illustration.

One of the monuments of nineteenth-century French book production was Baron Taylor's *Voyages pittoresques et romantiques dans l'ancienne France*. Designed and edited by C. Nodier, J. Taylor and A. de Cailleux, it was to have been completed with state support, in thirty volumes, but ceased with the twentieth in 1860 because of financial difficulties. The first volume was published in 1820. Bonington, who spent most of his short working life in France, achieved his best lithographic prints with his contributions to this work. These take the form of remarkably controlled chalk drawings, and it has often been debated whether or not they are surpassed by those of Eugène Isabey, another contributor. Since Isabey used the wider tonal range which characterizes most French lithographs of this period, his drawings possess greater contrast and dramatic power than the more restrained images of Bonington. A number of British artists were also engaged with this work while it was in production, and some of the stones were printed in London.

Among other books were the French translation of
Goethe's *Faust*, with lithographs by Delacroix, published
in 1828, and the *Robert Macaire* of Daumier, published in
two volumes in 1839–40.

The reproduction of book illustrations by relief methods,
both in Britain and in France, became more widespread
and achieved high technical standards, as the work of the
Dalziel brothers and Richard Doyle, and of the French
engravers Gérard, Slades and Porret, bears witness. The
main reasons for this, apart from any competition which
lithography offered, were the ease with which the wood-
block could be set up with the type, and the astonishingly
high speeds at which nineteenth-century letterpress
machinery could run. Also, as the century progressed, the
introduction of 'in text' illustrations became very popular,
and it was easier to accomplish this using relief methods.

It is possible that the diversion of lithography to mainly
reproductive and commercial printing proved beneficial.
Its pace of technical development, while not as spectacular
as that of letterpress printing, was still sufficient for the
average powered litho press of the time, where the stone
reciprocated under an impression cylinder, to give an output
of 600 prints an hour. Had this not been the case, it is
doubtful whether Daumier would have left 4,000 litho-
graphs as a legacy of his many years of drawing on the stone.
Their pungent comment relied for impact on fairly prompt
publication.

It was recognized very early in lithographic history that
it was a 'democratic' art, in the sense that wealth was no longer
necessary for art patronage, but it is unlikely that its use as

(Left)
R. P. Bonington, 'Evreux', 1824.
From *Voyages pittoresques et
romantiques dans l'ancienne France.*

(Right)
Eugène Isabey, 'Radoub d'une
barque à Marée Basse', *c.* 1832.

(Below)
Thomas Shotter Boys, 'La tour du
Beffroi, Calais'. Lithotint, 1833.
Probably from the volume on
Picardy in *Voyages pittoresques et
romantiques dans l'ancienne France.*

Richard Roberts, 'The Vale of Llanelltyd'. Lithotint, pale buff and black.

Newton Field, 'The Owl'. One of a series of natural history prints. Printed by C. Motte, Paris, 1828.

Artist unknown, 'Glyndwr's Old Parliament House, Dolgelly'.

a positive force for democratic ideas could have been fore-seen. Daumier, over a period of forty years, first for *La Caricature* and then for *Charivari*, scourged the corrupt establishment of Louis Bonaparte, earning for himself several periods of imprisonment. Later, he turned to social satire, which possibly was a less risky occupation. Not only had lithography become a tool of commerce, Daumier made it a powerful political weapon.

In France, interest in lithography was sustained through-out the century, whereas in Britain, its decline continued until the eighteen-nineties. It has frequently been stated that this was caused by Ruskin's influence, as artists of this period were reluctant to incur his displeasure by practising it. His writings on the subject are, however, ambivalent: 'Let no lithographic work come into your house if you can help it, nor even look at any except Prout's or Lewis's' (*Elements of Drawing*).

There is no doubt that his authority among artists and patrons was very strong, but their reaction does seem to be extreme in view of his other writings on the subject. While it is true that he found unpleasant certain aspects of com-mercial lithography, especially the highly glazed reproduc-tions of paintings, this did not prevent him from using the medium for the reproduction of his own drawings when the occasion suited him. His attitude towards the more creative side of the medium may be characterized by his praise of Samuel Prout:

. . . I repeat there is nothing but the work of Prout which is true, living or right in its general impression, and nothing therefore so inexhaustibly agreeable . . . but his excellence no one has ever approached, and his lithographic work [*Sketches in Flanders and Germany*] which was, I believe, the first of its kind, still remains the most valuable of all, numer-ous and elaborate as its various successors have been. . . . Their value is much increased by the circumstances of their being drawn by the artist's own hand upon the stone, and by the consequent manly recklessness of subordinate parts . . . which is of all characters of execution, the most refreshing . . . compare this . . . with the wretched smoothness of recent lithography' (*Modern Painters* Vol 1).

After Engelmann had patented chromolithography in 1837, colour printing developed rapidly, and it is only in retrospect that we can see that Ruskin's judgement of some of the work was unnecessarily harsh. Perhaps many of the pieces were not great art, but some of the lithographed music covers and illustrations produced during the Victorian period possessed great charm and not a little taste.

Unfortunately not all of this colour printing was creative. The process was extensively used for reproductions of paintings which were either commissioned by the printers for this purpose, or else chosen from paintings which had become popular at the Academy's exhibitions. The printers

were willing to pay the artist large fees for the rights of interpreting the pictures by chromolithography. Some of these are technically perfect, demonstrating the advances which had been made in presswork and colour registration during the previous few decades.

The only serious rival which lithography had for this sort of work was the delightful but painstaking colour prints of George Baxter, whose working life extended from 1830 to 1860. He used a relief process based on woodblocks, with a linear key drawing etched in relief on zinc or copper. These prints – which, incidentally, have now become collector's pieces – show a technique as brilliant as chromolithography in presswork and registration, though many of them suffer from the gloss which comes from extensive overprinting. However, Baxter could never match the size of a large-scale lithograph, even though he rivalled them in the number of blocks he used in a print, which could be anything up to twenty.

The normal method of working a complicated lithograph was to make a careful tracing of the original painting or other copy, which would act as a key to all the colours which followed. This key, where every colour change was outlined, when transferred to the stone, was usually printed in a light grey. Its position in the printing sequence could be at the beginning or at the end. The pale opaque colours were printed first, followed by the darker, transparent ones. The breakdown and separation of the original and the choice of the colours for printing was part of the job of the lithographic artist.

This method of working was well established by the second half of the nineteenth century, and must be clearly understood before Toulouse-Lautrec's revolutionary methods can be appreciated.

To lithography, as he did to his painting, Toulouse-Lautrec brought a superb draughtsmanship and an iconoclastic attitude to the past. Dispensing with the limitations imposed by the key, but imposing his own discipline of a restricted number of colours, he allowed them to flow across the boundaries of the shapes so that the complete design was not fully realized until the final stone had been printed. Thus, breaking with tradition, he established the road along which Bonnard and Vuillard were to follow, more poetically perhaps, but never with more urgency.

Towards the end of the century, lithography was solidly entrenched as the major printmaking medium in France, and enlightened publishers like Vollard and Kahnweiler commissioned artists to lithograph portfolios of related prints and also to use the medium for the decoration and illustration of fine books. Among these collections of prints are 'Quelques Aspects de la Vie Parisienne' by Bonnard and 'Paysages et Intérieures' by Vuillard.

Apart from the 350 posters and programmes which he lithographed, Toulouse-Lautrec made a number of prints

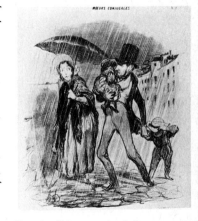

Daumier, 'Mœurs conjugales'.

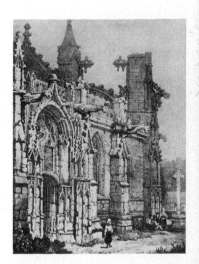

Samuel Prout, 'Church at Argue', 1821.

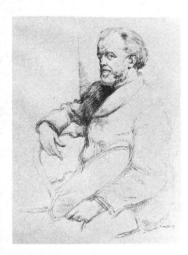

William Rothenstein, 'Portrait', 1897. From *English Characters*, published in 1898.

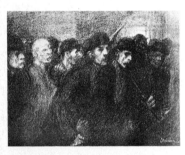

Steinlen, 'Workers leaving the factory', c. 1905.

Frank Brangwyn, untitled lithograph, c. 1905. Printed on brown paper.

and used the medium for book illustration. His album, 'Elles', is a series of lithographs composed of chalk drawings and colour prints, which are at once ironic and tender.

These artists, among others, were influenced by the Japanese colour woodcuts which had been introduced into Europe in the eighteen-sixties. The qualities which they demonstrated, those of simple rhythmic shapes, flat colour and texture, were well learned.

A sadder picture emerges from Britain at that time. When her artists were invited to contribute to a centenary exhibition in Paris in 1898, commemorating Senefelder's discovery, hardly one could be found who knew anything about the medium. Hartrick describes how the crisis was overcome, in his book *Lithography as a Fine Art*. Shannon, William Rothenstein, Ricketts, Whistler and Pennell were making monochrome prints, but except for the work of the last two artists, these are rather unadventurous. Perhaps the best are by Whistler, who was experimenting with thin washes in some successful lithographs on London.

Pennell's major work in the medium was his collection of transferred chalk drawings recording the building of the Panama Canal. Some of these are monumental in concept, reminiscent of Brangwyn's prints. In many of them he employed a very high eye level and used strong contrasts of tone and scale. Before he started the project, Cornelissens of London made for him some special chalk-grained transfer paper on which to work. After completing the series, he returned to the United States, and the drawings were transferred to the stone by a printer in Philadelphia.

In 1910, a number of artists including Pennell, John Copley, A. S. Hartrick (who was later to be involved with autolithographed war posters), Blampied (better known for his *Punch* drawings), Brangwyn and Ethel Gabain founded the Senefelder Club in London, to foster the making of lithographs. Even so, colour printing was neglected, the majority of the work by these artists being in monochrome. It is a sad reflection of the time that there was not more interchange of ideas between London and Paris. Exactly one hundred years before, even though Britain was at war with Napoleon, there seemed to be considerable liaison between English and French artists; Hullmandel, particularly, published many prints by French lithographers, including those of Géricault, who made a portfolio of prints drawn in London.

In Britain, it was not until the nineteen-thirties that the potential of the colour lithograph was realized, notably through the work of Graham Sutherland, John Piper, Barnett Friedmann and Eric Ravilious.

In Germany, the rise of Expressionism and its offshoots, the Die Brücke and Der Blaue Reiter groups, in the early nineteen-hundreds, gave a great impetus to the graphic arts in that country. The general philosophy within which

the member artists worked demanded an exaggerated and emotional use of colour combined with a strong, simplified line. This style of working is ideally suited to the print-making methods of coloured woodcuts and lithography, and the artists involved in these movements practised widely in these two media. Kandinski and Paul Klee, two artists more concerned with the Blaue Reiter school, later became members of the Bauhaus staff under Walter Gropius. The expressionist movement flourished until the early twenties and its influence on printmakers and illustrators is still very strong.

Perhaps Edvard Munch's lithograph, *The Scream*, in which, with a series of freely drawn brush strokes, he builds up a sensation of agoraphobic panic, best exemplifies this connection between woodcutting and lithography.

Working in an expressionist vein, but without formal attachments to Der Blaue Reiter, Käthe Kollwitz, over a long working life extending from the middle eighties of last century to 1945, made many passionate prints in the three media of relief, intaglio and planographic, on such themes as 'The Revolt of the Peasants', poverty, death and war. She was an active pacifist and her identification with the under-privileged was as strong as Daumier's opposition to corruption. Such was her stature, that from 1933, apart from being forbidden to publish her work, she remained unmolested until her death near Berlin in 1945. It is interesting to note that some of her powerful lithographic images dating from the twenties were plagiarized and used in conjunction with propaganda material published by the German government during the Second World War.

Although the visual arts in France between the wars were to a large extent dominated by Picasso, his major interests at that time were painting and etching. His twenty or so incursions into lithography formed more of an extension to his drawing rather than demonstrating his usual radical manhandling of a new medium. The most prolific and creative lithographers were the group of artists who were originally labelled 'Fauves': Matisse, Derain, Marquet and Rouault. Matisse's many black-and-white lithographs display a sparkling quality, comparable to Goya's.

The early post-war years were an intensely creative period for lithography, as they were for the other arts. Now, for the first time, British artists were making colour prints which, both in quality and number, could take their place with those of the Paris school. Generally, the work was in a highly romantic vein and this characteristic did not seem to be confined to any one country. For several years, complete abstraction was eschewed.

Among the younger painters working in Britain, Michael Ayrton, John Minton, James MacBride, Ceri Richards and Robert Colquhoun could all be classed as painter–lithographers in this new wave of romanticism, while Edwin Ladell, Julian Trevelyan and Bernard Cheese lithographed

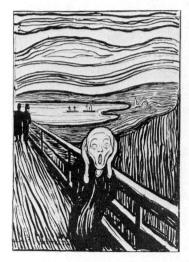

Edvard Munch, 'The Scream', *c.* 1895.

Käthe Kollwitz, 'Deliberation'. From the series 'The Weavers' Revolt', 1898.

more prolifically, mainly in the genre of landscape and topographical illustration. Of the established artists, Henry Moore, Graham Sutherland and John Piper maintained a steady output of prints.

This period was also noteworthy for the advent of a new method of patronage, with the commissioning of lithographs for display in the many Lyons' teashops, while London Transport continued with Frank Pick's enlightened policy of commissioning autolithographed posters. Artists involved with these projects included Edward Bawden, William Roberts (one of the original Vorticist group), Charles Mozley and John Minton. One other unlikely patron was the Football Association, which organized a print competition under the title 'The Sportsman in British Life'.

The Festival of Britain (1951) and the coronation of Queen Elizabeth (1953), were also occasions which were marked in similar ways by the Artists International Association and the Royal College of Art. The coronation lithographs were made within a set range of subjects, depicting aspects of the pageantry of this state occasion. About this time, the School Prints project was started and these double crown, original, but unsigned lithographs were sold for ten shillings or a pound each. Artists contributing to this series included Edwin Ladell, Michael Rothenstein and Ceri Richards.

Picasso was still the dominant force in France. In 1945, Mourlot, the master lithographer, persuaded him to draw a set of plates, and for the next seven years he concentrated most of his energy on the medium, using his great skill and assurance in the production of a long series of large-scale prints, both in colour and monochrome. Apart from exploiting traditional techniques, he devised many of his own, involving gouache, collage and transfer paper. Many of his plates were extensively reworked after transferring. For example, using the coloured lithograph *La Femme au Fauteuil* as a starting-point, Picasso took each of the five plates and used them as bases for further prints, making a total of twenty-seven different lithographs on the same theme.

Of the other long-established artists working in Paris, Matisse, Leger, Braque and Chagall lithographed consistently during the years immediately following the war.

Lithography, which had enjoyed a steady and logical development from its first use as an original medium, underwent a qualitative change during this period, mainly initiated by the work of Picasso, and as a consequence, both the scale and the character of the work performed since the nineteen-fifties is very different from that which went before.

Picasso, 'La Femme au fauteuil'. Black and white lithograph developed from one of the five colour plates of the original print bearing the same title. November/December 1948.

LITHOGRAPHY IN THE USA

Lithography was a late starter in the States, not being introduced until the Pendleton brothers set up a press in Boston in 1818. It is said that their most popular print was a portrait of George Washington, published in the early eighteen-twenties, and rendered on stone from a painting made by Gilbert Stuart thirty years previously. However, Bass Otis is generally credited with making the first original American lithographs, a series of small landscapes which were published in 1820 and thereby just missed being classified as incunabula.

Currier and Ives, 'Hauling Logs', date unknown.

The medium proliferated rapidly in response to the needs of the many settlers who were entering the country, so that the emphasis was on large editions. For this reason, American lithography developed very strongly in the form of a popular art. Although some contributions were made by Thomas Cole and Winslow Homer, members of the Hudson River school of landscape painting, the mid-century period was dominated by the firm of Currier and Ives, who, during a period of nearly fifty years, produced over 7,000 lithographs at an average of three each week, depicting the day-to-day events in the life of this energetic young country. Each print of the 7,000 editions was coloured by hand.

However, this native work was outside the mainstream of lithography, and the American artists most directly involved with its history were the expatriates who had settled in Europe, Benjamin West at the beginning of the nineteenth century, and Pennell and Whistler at the end.

In some ways, American artists were quicker to learn from *avant-garde* movements in Europe than the Europeans themselves, and the graphic work produced in the States during the early part of the twentieth century reflects a strong expressionist influence. Some of the prints by John Sloan, George Bellows, Charles Sheeler and Adolph Dehn possess considerable power, especially when the subject-matter was drawn from the poor and deprived in the large cities. This is most marked in lithographs executed during the depression years of the late twenties and early thirties.

The most far-reaching revolution to take place in American art occurred during the fifties, when quite suddenly they ceased to follow European trends, and themselves became initiators of world movements, first with Abstract Expressionism and then with Pop and Op art. As a result of this, their graphic output became more significant, particularly during the latter two movements. At first, this was manifested by a wide acceptance of the screen-printed image, but lithography is now playing an increasingly important role both in its traditional forms and in conjunction with photographically derived imagery.

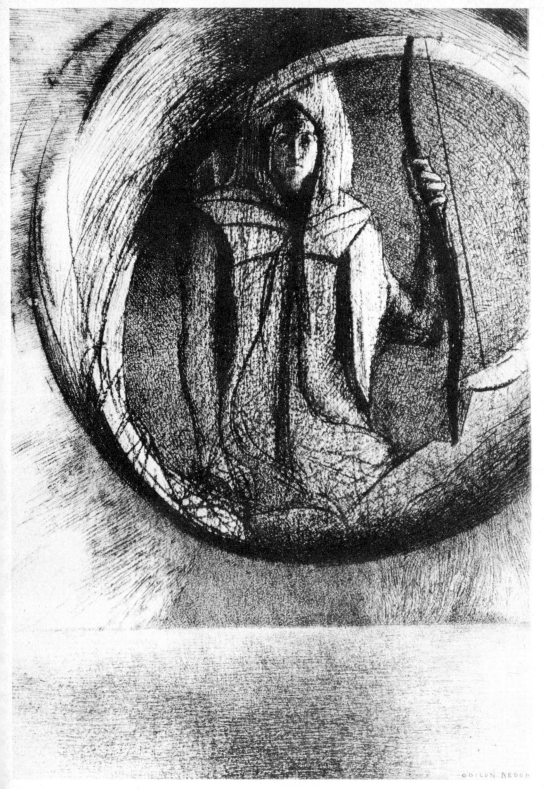

Odilon Redon, 'L'idole astrale: l'apothéose', *c.* 1880.

2 The basic chemistry

Lithography is unlike any other printing process in that its method of working is not immediately apparent to anyone seeing it demonstrated for the first time. Its printing and non-printing areas lie in the same plane, unlike relief methods, where the printing surface is raised above the non-printing areas, and intaglio methods where the reverse holds true. In these, there is a physical separation between the image and the non-printing background. Thus, lithography belongs to a third method, the plano-graphic, a category which includes the only other known method, collotype, which relies on the reticulated surface of gelatine, and is entirely photographic in principle.

Lithography is the only printing method in which a spontaneous drawing can be made, subject to the artist's own ability and confidence, which can be processed to form a printing surface capable of giving, under the right circum-stances, an almost unlimited number of proofs.

The principles of the craft are based on the natural phenomenon known as 'adsorption', that is, a union of two substances which is neither truly physical nor truly chemical. The most common everyday example of this action is the way in which soap combines with dirt to remove it from the hands. A corollary of this is the behaviour of soap in hard water, when the limestone in the water adsorbs the soap to form a greasy, insoluble precipitate.

This, in fact, is the chemical basis for the lithographic process. When a drawing is made on lithographic stone (limestone), using a crayon or ink composed mainly of soap, the fats combine with the stone to form a greasy image which is insoluble in water, and which can only be totally removed by grinding away the surface. Since litho stone is quite porous, the longer the fat remains in contact with it, the deeper will it penetrate.

If the undrawn areas are treated with a solution of gum arabic, they will be effectively sealed from any further contact with the grease. The gum will penetrate into the pores of the undrawn stone, and because of its hygroscopic nature, will always be ready to take up water when it is applied. Of the two different areas, the gummed portion is the more easily removed. This can be done by dissolving the limestone beneath it.

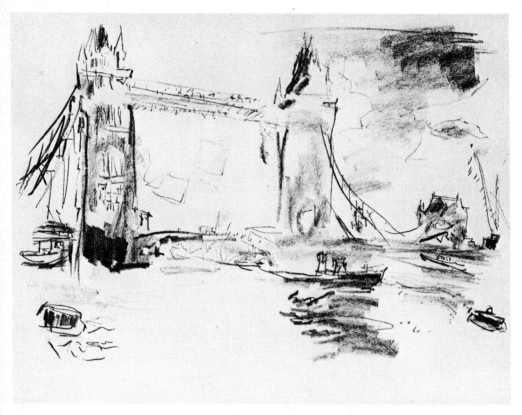

Oskar Kokoschka, 'Tower Bridge II', 1967. From the series 'London from the River Thames'. 25 in. × 35¾ in.

When both the image drawing and the gum have dried, it is possible to wash off the surplus gum with water, and clean off the ink from the image with white spirit. It is only when this stage has been completed that the division between the printing and non-printing areas can be fully appreciated. Although there is very little difference in colour between them, their qualities are well contrasted. The image area is not only dry, but greasy in texture, while the non-printing area is completely wet. Water will not stay on the image, and it is impossible to deposit grease on the wet areas.

This principle of adsorption operates to a lesser extent on marble, which is a harder form of limestone, and on both zinc and aluminium. It can also be applied to the paper plates which have been in use over the past thirty years. It does not, however, operate on other metals such as steel and copper.

It is believed (according to the Society of Chemical Industry) that the fat from the ink forms a monomolecular layer on the limestone or metal owing to some form of interlocking in the molecules, and that this layer is sufficient to transform the quality of the surface in such a way as to

make lithographic printing possible. Therefore, in using the process, the artist has two modes of attack, either on the image or on the non-printing background, and the action of any substance or chemical used in a graphic way must be assessed from these viewpoints. Broadly, will it affect the image or the gum? Can the water-rejecting properties of the one be strengthened without diminishing the grease-rejecting properties of the other? Or vice versa? Certain substances which can be used are neutral in their action. They can be applied to the plate as a temporary mask, and when removed, the original surface has suffered no deterioration in its performance. Soap is a compound formed by treating fats, or tallow, with either caustic soda or caustic potash. This changes the character of the fat so that it becomes equally soluble in water or spirit. When it has adsorbed the stone or the metal, it becomes insoluble in water. Because the image is in depth on the stone, it is more difficult to remove. Repeated applications of nitric acid will eventually dissolve the limestone beneath the image, which will therefore become detached from the stone.

Because the image on a plate lies on the surface, and is therefore vulnerable, it can more easily be returned to a water-soluble condition by the application of a caustic solution. In this state it can be rinsed off.

Before any processing is carried out on the plate, it is customary to reinforce the image by coating it with a highly greasy compound derived from purely mineral sources. This acts both as a protection to the tenuous image beneath it, and also as an ideal base on which to build up a film of printing ink.

With regard to the non-printing background, although the gum in its damp state will protect the stone or plate from any image-forming grease, this protection is not durable, and the gum has to be treated with reinforcing agents to enhance its grease-rejecting properties. These agents take the form of dilute acids, which unfortunately, if too strong or used to excess, can damage the image. It is generally accepted that these effects can be minimized by reinforcing the image with certain acid resists while this process of 'etching' is carried out.

Among substances which are neutral in their action on the plate or stone, are water, any spirit which evaporates completely without leaving a residue, and certain solutions such as shellac in methylated spirits or egg albumen in water, which when they have dried and their function is complete, can be easily cleared with the appropriate solvent.

To the artist who understands the many different ways of applying them, and their actions, these substances can give unlimited scope in the realization of his images.

Bernard Cheese, detail of wrapper for the house publication *Bowater Papers*, 1954. Overprinting with chalk and dragged brush textures. The four plates are printed in vermilion, light cerise crimson, dark crimson and dark turquoise.

3 Stones, plates and equipment

STONES, THEIR ADVANTAGES AND DEFECTS

Any artist who has once worked on stones will most probably prefer them to plates, and until fairly recently they were considered to be infinitely more versatile in the range of textures and effects which they were capable of giving to the lithographer. However, the experimental work carried out on the plate by artists since the war has dispelled that belief.

The limestone used for the craft is quarried in Bavaria, near the towns of Solnhofen and Kelheim; in fact, it is known as 'Kelheim stone'. The colour varies from a warm biscuit to a darkish grey, and this is an indication of its final hardness, the lighter colours denoting the softer stone. It occurs naturally in strata, and being soft when quarried, is easy to handle, but as it gradually dries in the open air it hardens to the texture we know. Other qualities of stone have been discovered in various parts of the world, but they are said to be inferior to the German variety.

Stones are cumbersome and heavy compared with plates of the equivalent size, and instead of unwrapping a neat parcel from the plate grainers, the stone must be prepared for drawing by the artist, unless alternative labour is available. It must be admitted that in one sense, personally preparing the stone is an advantage to the artist, who can choose and control the exact quality of surface he would like on the stone. The main criticism is the time and energy spent in cleaning away the old work and preparing the surface to receive the new drawing.

Generally, the harder the stone, the less porous it is, and therefore the less sympathetic for drawing. This division has been recognized almost since the discovery of lithography, and it has been found that harder stones can take a glass-like polish for use with fine pen work, and also can take a sharp grain. The softer stones are more suitable for use with a granular surface to receive a rich chalk drawing.

The stones should be of minimum thickness in proportion to their size, in order to withstand the very considerable pressure which is exerted on them during printing. As a rough guide, a stone 10 in. × 8 in. should be about $2\frac{1}{2}$ in. thick, while a stone 30 in. × 20 in. should be at least $3\frac{1}{2}$ in. thick. A stone of this size would weigh the best part of

1½ cwt, and is really too heavy to carry around. As stones are worn down through use, they become too thin, and it is common practice to cement two thin ones together.

Though hard, the stones are brittle and require careful handling. When they crack, as inevitably they will if struck on one of the edges, they fracture conchoidally – hence the number of stones with scalloped edges.

Blemishes found on stones

There are also a number of defects occurring naturally in stones and thus outside the artist's control, but which at the same time present a challenge to his ingenuity. It has been said that the perfect stone has yet to be quarried. This may be an exaggeration, but it is certainly true that the larger the stone, the more imperfections it is likely to contain.

Brown iron stains can cover most of a stone's surface, but do not affect the working in any way. They can be disregarded.

Areas of *white mottling* are generally softer-textured than the rest of the stone and are more affected by the nitric acid etch. If they cover an excessive area and it is impossible to avoid drawing over them, the stone should be rejected.

Felspar crystals are quite common, but fortunately occur singly. As they do not react to grease, the drawn part of the image should avoid them, but on non-printing areas they are quite harmless.

Cracks are the most common defect appearing on stones, and were formed when the rock was laid down in prehistoric times; subsequently they became filled with molten silicon. Perversely, these cracks will most likely print as a white line across a dark area, and as a black line on a non-printing area. The latter can be cured by scraping down the surface on and around the crack so that it is too low to take ink from the roller. As an added safeguard, the area should be given a strong etch. If the crack cannot be avoided by the drawing, the stone should be rejected.

EQUIPMENT

Before drawing can proceed, the surface of the stone must be prepared, and for this, the following items will be needed.

1 Litho stones of the required size.
2 Levigator. This is a heavy cast-iron disc, from 10 in. to 12 in. in diameter and about 3 in. thick, with an upright handle near the circumference on the top surface. The casting has a number of holes connecting the two flat surfaces so that water can be admitted while the levigator is in use.
3 Straight-edge.
4 Bow calipers (large).
5 Linen prover. This consists of a magnifying lens mounted on a folding stand with its foot opening at the

Chromolithographed child's cut-out sheet. German, *c.* 1900.

I saw them --- and they were the same,
They were not changed like me in frame;
I saw their thousand years of snow
On high --- their wide long lake below,
And the blue Rhone in fullest flow;
I heard the torrents leap and gush
O'er channel'd rock and broken bush:
I saw the white-wall'd distant town,
And whiter sails go skimming down;
And then there was a little isle,
Which in my very face did smile,
The only one in view;
A small green isle, it seem'd no more,
Scarce broader than my dungeon floor,
But in it there were three tall trees,
And o'er it blew the mountain breeze,
And by it there were waters flowing,
And on it there were young flowers growing
Of gentle breath and hue.
The fish swam by the castle wall,
And they seem'd joyous each and all:
The eagle rode the rising blast,
Methought he never flew so fast
As then to me he seemed to fly.

Page from a chromolithographed edition of Byron's 'Prisoner of Chillon', printed about 1869.

focal length of the lens. The foot has an opening in it over which slides a calibrated measure. As its name implies, it is really designed for use in the textile industry, to count the number of stitches per inch on woven materials.

6 Squeegee. A hard rubber blade with a wooden handle – one about 18 in. in length would be adequate.

7 Gritstone or pumice block. Originally these were made from naturally occurring pumice, but good substitutes are now made by bonding abrasive powder into a small brick.

8 Snakestone. This stone which comes from Scotland and is also known as Water of Ayr stone, is supplied in blocks of various sizes, and also in 'slips' about the size and shape of a Conté crayon. It is a hard stone about the colour of slate and its mild abrasive qualities are capable of giving the surface of the litho stone a glasslike finish.

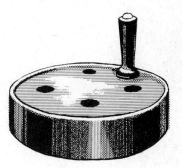

Levigator.

9 Grainer or marble muller. These are used for identical purposes, that is, putting the final grain on the stone. The muller is a piece of turned marble about 6 in. in diameter, made with a ball-shaped top to fit into the palm of the hand. The grainer is made in the studio, from a broken litho stone. It should be wedge-shaped with a base area no larger than 5 in. × 5 in. Its advantage is its economy.

10 Coarse grinding sand.

11 Silver sand. This should be obtained in various degrees of coarseness, to match the sieves.

12 Sieves. The range should be: 40, 60, 80, 100, 120, 140, 180 and 200 holes per inch. This should cover most needs, but finer grades are obtainable if required.

13 Carborundum powder, pumice powder, aluminium oxide powder, glass powder. These are all very good abrasives, and are generally more expensive than sand. Most of them can be obtained in finer grades than the sand, and if a choice has to be made, pumice powder should be chosen as it can be of great help when working on the plate. They are more economical in use than sand as they tend to keep their cutting power longer.

14 Stone file. This is about 15 in. long, flat and double-sided, with a very coarse and quick cutting action. It is used for the initial rounding of the edges of the stone after graining.

Linen prover. The sliding calibrated measure is shown partly withdrawn. The hole in the base is about 1 in. square.

15 Rasp. This is used for the same purpose as the stone file, but is not as efficient.

16 File. The use of the stone file scores the edges, and an 8 in. file will smooth these away. Note: files are used while the stone is wet, and unless they are dried immediately after use, they will rust, and their cutting power will quickly be destroyed.

17 Graining trough. This, by its nature, must be a fixture, so some care must go into the decision where it is to be placed. The trough is made of timber about 1 in. thick (teak is to be preferred) and lined with lead to make it water-tight. A centrally placed drainage hole is incorporated in the base during manufacture. Its dimensions should be such

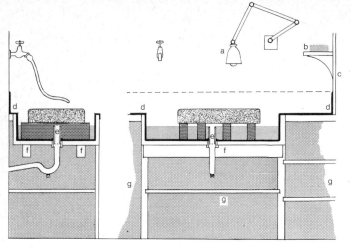

Graining trough. *a* Adjustable lamp. *b* Grit-free shelf for pumice, snakestone blocks etc. *c* Thin screen to prevent sand from encroaching on other working areas. *d* Lead or zinc lining for trough, bench and surrounds. (Note: all joints must be firmly soldered to make the coating waterproof. Lead is to be preferred, as it does not react with spilt acid.) *e* Removable pipe-stem. *f* Joists for supporting trough. Timber of 6 in. × 3 in. section should be adequate. *g* Storage cupboards for sand, sieves, files etc.

that it can accommodate the largest stone likely to be used in the studio. A trough about 2 ft × 3 ft and about 6 in. deep should satisfy most requirements. A pipe stem about 3 in. long is inserted into the drainage hole so that water can be maintained at that level in the trough. The whole unit can then act as a sump instead of letting the sand flow away and clog the plumbing. The sand must be removed from time to time. The trough is best placed next to a large sink, so that a hose can be attached to an existing tap; alternatively, another tap with a hose attachment can be installed quite cheaply. This should be fitted at one end of the trough, out of the way of the stones when they are standing up. Stout wooden battens are placed on the floor of the trough to support the stone. These should be deep enough to raise the top of the stone well clear of the trough's edge, and sufficiently wide to make a stable platform.

PREPARATION OF THE STONE

This procedure falls into three parts: grinding the stone (i.e. cleaning off the old work and levelling the surface), polishing the surface and graining the surface.

Grinding

This can be achieved in two ways, either by using another stone of approximately the same size, or by using the levigator.

The aim is to clear away the old work as quickly as possible and to make the surface level and as near parallel with the bottom of the stone as can be achieved. This last item is not as straightforward as it might seem, because most stones are badly pitted on the underside. Generally, the bow callipers will indicate whether too much inaccuracy is being introduced, and much of the unevenness can usually be eliminated by packing when the stone is on the press.

In method 1 (using the levigator), the stone is carefully lifted on to the battens in the graining trough, broadside

to the front. With a hose, the surface is thoroughly wetted. The old image is washed out with white spirit until all the ink has been cleared away.

1 With the hose, wet the surface and clean away the residue of ink and white spirit.

2 Using a 40 sieve containing a shallow layer of coarse sand, shake about half a cupful on to the surface of the stone.

3 Gently place the levigator on the surface, taking care not to damage the stone. Swinging the handle, spin the levigator in an *anti-clockwise* direction over the surface of the stone. It will be found that the wet sand will ease its progress as well as abrading the surface. Should the levigator be spun in a clockwise direction, the handle may unscrew, so that the cast-iron disc flies off, causing considerable damage. The sand will gradually be worn to a fine sludge during the process and it must then be replaced.

4 Remove the levigator, hose down the stone and sprinkle on more sand. Replace the levigator and regrind. This process is repeated until all the old work has disappeared. Should the sand become dry, it is possible to add water through the holes in the levigator.

Check the level of the surface each time the sand is changed, so that more localized grinding can be done. After hosing the used sand away, the surface is dried with the squeegee. When using the straight-edge, the stone is always tested along the diagonals and across the middle of the sides. If any hollows or bumps are evident, then regrinding must continue. If there is a small hollow, it can be checked by placing a small piece of tissue paper in it before laying on the straight-edge. If the paper can be pulled from beneath the edge, then the hollow is too deep and must be ground out.

Method 2 is similar, in broad outline, to the previous one.

1 The old images are cleaned from the two stones that are to be used, with white spirit.

2 The first stone is placed standing on one of its longer edges and with the working surface facing the front, on the battens towards the back of the trough.

3 The second stone is laid upon the battens.

4 Both stones are hosed with water.

5 Coarse sand is sprinkled on the recumbent stone through the 40 sieve.

6 The standing stone is then gently lowered on to the surface of the horizontal one.

7 The top stone is moved, using a reciprocating motion from front to back, so that each time it will overlap the bottom stone by several inches, first at the rear, and then at the front. At the same time as this broad pattern of movement is followed, the top stone is gradually moved laterally along the length of the bottom stone so that it alternately overlaps each end by just under half its length. The object of

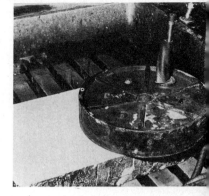
Grinding the stone with the levigator.

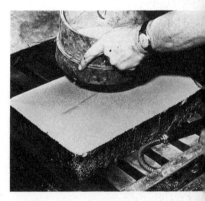
Shaking sand through the sieve on to the wet stone.

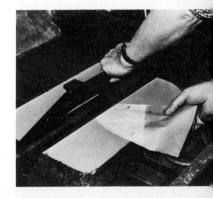
Checking flatness with straightedge and tissue paper.

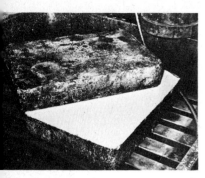
Stone grinding, using two stones of similar size.

this is to even out the wear on each of the stones as far as possible.

8 As the sand loses its abrasive power, it must be changed. The top stone is carefully replaced in its standing position and both stones are hosed down. The sand is renewed and the whole process repeated. It will be found that the two stones will wear in different ways, the top one becoming slightly convex and the bottom one, concave. If the position of the stones is alternated every second time the sand is changed, the tendency for uneven wear should be countered. The straight-edge should be used as frequently as before, but small corrections to hollows and bumps can be carried out separately on each stone with either the levigator or the muller.

Grinding down the old work can be a disappointing process, not to say tedious, especially if the work has been on the stone for a long while, and has penetrated it relatively deeply. Also, when the stone is wet it looks really clean, and it is tempting to move on to the next stage. The old image can be tested, while the stone is wet, by lightly rubbing across it a finger charged with a little press black. If the ink takes to the image, then the process of grinding must continue. It will also be noticed that although the image, if it is still present, may not be visible when the stone is wet, it will show up fairly clearly when the stone is dry, by a slight difference in colour.

The time when the sand should be changed can be judged with practice. When the sand is biting into the stone, there is a rewarding, sharp, abrasive sound. As the sand becomes worn to a paste, this gradually stops and the levigator – or the top stone, as the case may be – begins to bind on the bottom one as a vacuum is formed between the two surfaces. If two stones have been used in grinding off the old work, the spare one, when dry, should be wrapped in clean paper and sealed with tape, until it is needed.

When the stone is quite clean, it is ready for the next stage. Firstly, the stone must be thoroughly hosed down so that no grain of sand is left, either on its surface or on its sides. There is only one sure method of checking this. While the hose is playing over the surface, lightly pass the fingers over every part, working from the middle to the edges, and then continue down the sides until every speck has been washed away. The reason for this will become apparent with the next process.

If a coarse grain is needed for the projected work on the stone, then after rounding the edges and as soon as the stone is dry, it is ready for drawing. If a finer grain is needed, the following procedure must be adopted.

Polishing the stone

It is not possible to obtain an effective and finer grain by working directly over the coarse surface left by the pre-

ceding stage with a grainer and fine sand. The coarse surface has to be removed by smoothing it down with a gritstone or pumice block, and then polishing it with the snakestone to give it a mirror-like surface. Should even one grain of coarse sand be left on the surface of the stone, when pressure is exerted on the blocks all the weight will be transferred to the stone through the grain of sand, leaving a deep score which will have to be eradicated by a repeat of the whole grinding process.

It is also advisable to have near by a shelf or ledge which is used for no other purpose but holding the pumice or snakestone blocks when not in use. The area surrounding the graining trough always has particles of grit or sand lying about waiting to be picked up, so care will save much unnecessary work.

1 The stone is hosed down with water, making sure that there is no grit present.

2 Using the pumice block in a circular motion, exerting firm pressure with both hands, the wet surface is worked a small area at a time, approximately 8 in. square, until the whole stone has been treated. Water should be added as necessary, when the surface becomes too dry to work. The stone is then hosed and squeegeed, again making sure that no grit has found its way to the surface. During this process, the pumice will have covered the surface with a series of fine scratches, and these must be polished out with the snakestone block.

3 The snakestone is washed to remove any grit, and the litho stone is hosed down again.

4 The snakestone is used in such a way that the angle between one of its large flat surfaces and its adjacent long edge is the part which does the polishing. As previously, the litho stone is kept wet, but the snakestone is used in a planing motion. The surface is treated similarly to the method employed using the pumice, that is about 8 in. square at a time.

5 On completion, the stone is thoroughly hosed down and dried.

6 With the aid of the linen prover, the surface of the stone is checked for any residual scratches. These must be treated again until they have been polished out.

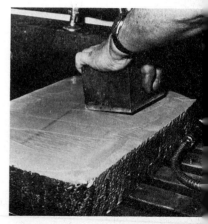

Polishing the stone with a snakestone block. Note the angle at which it is held.

The surface will now have an extremely smooth finish, and is ideal for the receipt of fine pen drawing, or transfers. After the edges have been rounded and the stone thoroughly washed and dried, it is ready for use.

Graining

1 A shallow layer of the chosen grade of sand is placed in a sieve of the same grade.

2 The stone is hosed down, and the sand sprinkled through the sieve on to a small area of the wet surface.

3 Using the muller or the wedge-shaped grainer in a circular motion similar to that used with the pumice block, a limited area at a time is treated, until the whole of the surface has been covered. A constant check should be kept on the state of the stone, and the graining sand must be changed frequently before it has lost its abrasive power. Experience, and the use of the linen prover, will give adequate guidance on the progress of the graining. Two conditions should be avoided. In the first, the surface will appear quite smooth, with infrequent pitting, the amount of which will depend on how long the graining continued; this is caused by insufficient graining. The second condition results from keeping the sand in use for too long, so that it becomes pasty in texture. The surface, in this case, will possess a grain without sharpness or character.

A good granular texture can be felt by pushing the finger nail along the surface of the stone (not over the image area). However, the most satisfactory method of checking is as follows. The stone should be allowed to dry, after hosing it down well to clear all the sand from the surface. The stone should be placed so that a low, raking light can shine across its surface from the back. Making sure that the linen prover is free from grease and grit, it is placed on the stone. It will be found that the light brings all the variations of the surface into clear relief, and when the magnified grain is seen through the lens, its character is clearly delineated; any unwanted scratches, or insufficient graining, or a flattened grain can be noted for later correction.

When the grain is satisfactory, the edges of the stone are rounded to provide a gradual transition from the vertical to the horizontal, first by the stone file, then using the flat file, and finally by smoothing with a pumice block. This should be done while the stone is wet. During this procedure, should the file slip and score the surface, the whole operation of grinding, polishing and graining must be repeated. Rounding the edges serves a twofold purpose. A sharp corner will take up ink and scum more easily than a rounded one, and it is also more prone to fracturing.

Finally, the stone is thoroughly hosed and washed, and allowed to dry. It is then ready for drawing. If it is not required at once, it must be wrapped in clean paper and stored.

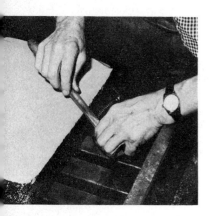

Rounding the edges with a file.

PLATES, THEIR ADVANTAGES AND DEFECTS

The two metals which respond to the chemistry of lithography are zinc and aluminium, in that order; zinc was used quite early in lithographic history. Their most obvious advantage over stones is their portability and lightness, and thus they can more readily be used as an extension to the sketchbook. They are also more economical in storage space, but can only be used once before being returned to

the factory for regraining or exchanging, under the various schemes which exist.

Although stones and plates are often bracketed together in considering their potential lithographic qualities, the differences between them are quite marked. The principles of the craft dictate that while the printing process is being carried out, the non-printing areas must be kept damp in order to reject the greasy ink from the roller. The stone, being porous, has a decided advantage over the plate in that it can hold water in the pores of its surface, whether the stone is grained or polished. The plate, though able to adsorb grease, cannot be penetrated to any real depth. So in order that the surface can carry sufficient water to make a fine film, it has to be grained.

Graining plates is a specialized business, usually performed by firms properly equipped for this type of work. A number of plates are clamped to the floor of a large, water-tight tray which is able to reciprocate in a horizontal plane. After the plates are fixed, abrasive powder, of a suitable grade for the required grain fineness, is put into the tray, in suspension in water, in a quantity sufficient to cover the plates. Some glass or porcelain marbles about an inch in diameter are introduced and the tray set in motion. The marbles rolling over the plates cause the powder to bite into the surfaces, preparing them anew. It is a very noisy process.

Another method, which is superseding the previous one, is an adaptation of the process known as sand–blasting, in which grit is blown under pressure against the surface of the plate, giving similar results to the previous method.

Graining approximately trebles the surface area of a plate, so that the area presented to the greasy ink and the gum arabic is also trebled. If a plate is inspected microscopically, it will be found, especially with zinc, that its grain is very different from the grain on stone. A stone grain could be said to approximate to the surface of a drawing paper, and is composed of rounded, steep hills, instead of the spiky hills and deep valleys of the zinc. The grain of aluminium is more crumbly, and would lie somewhere in between. The gum arabic is trapped in these valleys and, after etching, forms a tough, leathery surface which readily takes up water as soon as a damp sponge is passed across it.

Though it is possible to use ungrained plates, these present certain difficulties in working, and it is better to use the factory product, especially as the relative fineness of the grain can be specified when ordering the plates in much the same way as choosing the grade of sand when graining a stone. Normally, an 80 or a 100 grain is used for work which involves fairly broad chalking, but for finer and softer chalking, 120 or 140 is preferable.

Plates which are to be used for photographic images only have a much finer grain, of the order of 400. The reason is that original artwork is already broken up by the half-tone screen when the negatives are being made, and a

a

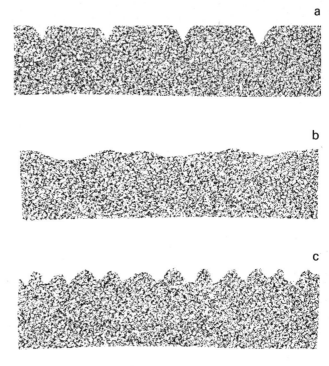

b

c

d

Comparison of stone and plate
grains. *a* Stone grain resulting from
insufficient graining time. *b* Stone
grain resulting from using sand
which has become pasty.
c Well-grained stone surface.
d Aluminium plate, showing
relationship to level of gum film.
e Zinc plate, showing characteristic
spiky grain and level of gum film.
It will be seen that the points of the
spikes, because of their shape, will
not hold gum; it is suggested that
this is the reason why zinc plates are
prone to scumming.

e

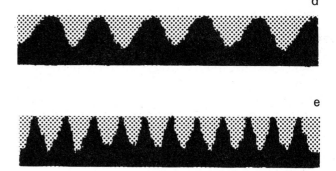

coarser grain would break up the image still further. The
great progress made in the quality of colour halftone litho-
graphic printing over the past two decades has been in part
due to the introduction of fine-grained plates, so that finer
halftone screens can be used in conjunction with them.

For artists wishing to use both drawn and photographic
images on the same plate, a grain finer than 140 should not
be necessary. In any case, fine-grained plates are designed
for the controlled, mechanical inking and damping on
rotary offset presses, and when used for hand rolling, as the
smooth damp surface has no friction, the roller slides
across the plate, feeding ink to the image only with diffi-
culty.

Zinc, it was noted earlier, will take a grain that is sharp, and this causes small pieces of fibre to be dragged from the sponges and rags used in the processing. This can be a minor problem, particularly when rolling up with a pale, transparent colour. Because of this spiky grain, and the metal's greater affinity for grease, it is more prone than aluminium to take up ink on the non-image areas. The softer grain of the latter metal is more easily desensitized, that is to say, made to form a non-printing area.

Aluminium is also a lighter metal than zinc, both in weight and colour: silver-white as against the dark grey of zinc. This makes aluminium a more attractive surface on which to draw, as the work shows up with great clarity. When used for colour printing, zinc suffers the disadvantage that greys and neutral colours of the same tone as the metal do not show up against the background. This can cause difficulty in judging the state of the image when the colour is being applied, especially if there is fine chalk work or texture with a tendency to fill in.

Aluminium does not accept grease so readily as zinc, and being a somewhat porous metal, both the grease from the drawing and the gum arabic will penetrate the surface. This makes the plate more difficult to resensitize in order to add more work. Aluminium also has the drawback of oxidizing easily, especially near the coast and in damp conditions. Some authorities claim that, to prevent oxidation, the metal should only be drawn while it is resting on a warm surface, as the surface can deteriorate quite rapidly if it is left uncovered for any length of time while being worked. Warming the plate would also have the effect of encouraging the grease to penetrate the grain.

One other important factor influencing the choice between the two types is the need to avoid having too many chemicals about the studio. Although some of these can be used on both aluminium and zinc, some are specialized for one or other metal. This stems from their individual chemical characteristics, zinc reacting violently to certain acids which do not affect aluminium, while the latter reacts violently to certain alkalis which do not affect zinc. Most of the chemicals used in lithography are potentially dangerous, some being classified as corrosive poisons, and others as highly irritant. From both the economic and the practical point of view, it would be better for the artist to choose one or the other. If lithography is going to be used extensively as a printmaking craft, as with any other activity the fewer operating uncertainties the better. As experience and knowledge of the effects of the materials and processes are acquired, it will be found that there is little to choose between the final results given by both types of plate.

In the case of schools, and printmaking workshops used on a communal basis, it naturally follows that both types of plate should be available for the students and artists who prefer them.

Paul Klee, untitled coloured lithograph, 1929.

4 Drawing the image

GRAPHIC MATERIALS

The essential property of drawing ink and crayons is to transfer to the stone or plate the fat which is indispensable for the formation of a printable image, and at the same time to show the artist the sort of mark he is making. Rubbing soap on a prepared lithographic plate will also make a mark that will print, though the nature of the image will not be apparent until the plate is being rolled up.

Ink is supplied in bars, and is prepared for use by being dissolved in distilled water, turpentine or white spirit according to the type of work in progress. Hard water from the tap is not normally used because of its lime content, but it can give an interesting speckled wash when the occasion demands it. There is a liquid form of litho writing ink which can be used directly from the container, and in this state it is ideal for large areas of solid tint. It can also be diluted with distilled water, but not with turpentine.

The method of mixing the ink, whether with distilled water or with turpentine, is the same. The underside of a flat tin lid is heated over a spirit lamp, bunsen burner or candle, and the exposed end of the stick of ink is rubbed against its upper side. The gentle heat melts the ink, which then runs on to the lid. Either distilled water or turpentine is added and mixed into the ink with a small brush. The degree of dilution depends on the purpose for which the ink is to be used. Drawing with a fine pen necessitates a thin ink, while painting a large area with an 8 or 10 brush will need ink of a creamy consistency. For dragged brush work, an even thicker ink might be needed, while for thin wash drawings, only experience can decide the strength of the mixture. When warming the lid, the heat must never be so severe that the ink begins to bubble, as this indicates that the grease in the ink is breaking down. Also, when mixing the ink with turpentine, it must not be forgotten that this is a highly inflammable spirit, and too much heat will make it break into flame.

Lithographic chalks or crayons are supplied in grades of softness, ranging from 00, which is very soft, to the hardest, number 5, roughly in the manner in which pencils are graded. Traditionally, a hard crayon was used on a fine-grain stone, 140 or even finer, while the softer crayons

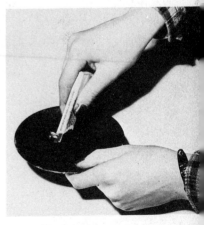

Mixing the writing ink.

47

were used on more open-grained surfaces. However, like many other traditions, this is no longer sacrosanct.

With regard to the composition of these inks and crayons, various recipes have been left by Senefelder. It is sufficient to say that all of them contain saponaceous fat and lamp black, the other constituents – wax, shellac and tallow – being added in varying proportions according to the formula required.

Gum Arabic

In some respects this has been regarded as the most important material used in lithography for, until quite recently, without it the whole operation would have fallen apart, as no other substance had been discovered which would effectively desensitize the plate.

Gum arabic is a true gum; that is, it is soluble in water, and completely insoluble in spirits or turpentine. It is obtained from tapping the bark of a certain species of the acacia tree, which grows around the shores of the Mediterranean, and in the countries bordering it. The best quality, as its name implies, comes from Arabia, and is colourless. Although other qualities are sold bearing the same name, they probably come from Africa; their colour ranges from lemon-yellow to red-gold, and they are somewhat cheaper. Gum comes in pebble-shaped lumps, mixed with gritty particles, usually of bark and parts of insects. To bring it to a usable state, it is placed in a jar and covered with cold water. It dissolves readily within a few hours, and is then strained through muslin to remove the foreign matter.

For normal work on the plate or stone, the gum is used in the consistency of thin cream, either plain, or with various proportions of nitric acid for stones, or with the tannic acid etch for plates. Plain gum should always be available in the studio, ready for use.

Acids used for etching and desensitizing

Nitric acid, in the concentrated form in which it is sold, a 60 per cent concentration, is a powerful and corrosive substance which emits an equally corrosive vapour. It is supplied in multiples of a litre, and when diluting it to the various strengths used in lithography, the greatest care must be exercised, as apart from the fumes, considerable heat is generated during the process. As with all strong acids and alkalis, nitric acid must always be added to the water drop by drop, so that the heat is able to dissipate. Should the water be added to the concentrated acid an explosion would be caused, spraying the glass container and the acid over everything near by.

The acid is used for both stones and zinc plates, but for completely different purposes. In its dilute form it attacks

limestone, liberating carbon dioxide in the process. Its effect on the stone is to enlarge the pores, enabling more gum to penetrate and at the same time forming the salt, calcium nitrate, on the surface. This substance has no affinity for grease, so nitric acid makes an ideal etch for desensitizing the non-printing areas of the stone. Its effect on zinc plates is described in the section dealing with resensitizing solutions.

Tannic acid is an organic chemical, widely distributed in nature, mostly in tree bark, although in its strongest concentration it is found in the gall nuts which the gall wasp makes on oak trees. Senefelder steeped and boiled these nuts, using the resultant liquid as an etch for zinc plates. Various patent preparations made from tannic acid or gall nuts are sold. Among these are Atzol, a gum-gallic etch, and Victory Etch, which is mainly tannic acid.

As tannic acid does not appear to affect the metal, but only the gum film, it is satisfactory as an etch for both zinc and aluminium. Its effect on the gum appears to be similar to its effect on hide, where it turns a skin, which would normally go brittle with age, into leather. After etching with tannic acid, the gum acquires a leathery quality which is resistant to abrasion and wear.

In more recent times, chromic acid salts have been used for tanning leather, as their action is similar to that of tannic acid. Because of this similarity of action, chromic acid has also been widely used for the past eighty years as a successful etch for plates, applied to the gum film. Many lithographers preferred it as it had a more positive effect than tannic acid and produced a cleaner plate. However, because of its progressively poisonous action on human tissue, its use can in no way be recommended.

For those who prefer to make up their own solutions, tannic acid can be obtained as a powder and is easily dissolved in warm water. When using this as a plate etch, the working strength of the solution must be discovered by trial and error.

Resensitizing solutions

These solutions are used to remove the gum film from the non-printing areas of stones and plates, to re-expose the metal or stone, so that it is once again capable of adsorbing grease. Their manner of operating seems to be similar, in that they are able to strike through the gum arabic to dissolve the thin layer of stone or metal underneath, to which the gum is attached. Unfortunately, owing to the different chemical characteristics of limestone, zinc and aluminium, a different solution must be used for each.

Acetic acid, the active constituent of vinegar, in its concentrated form is a sour, colourless liquid with choking fumes. It is used for resensitizing stones in the concentration of 3 parts of water to 1 part of acid.

Citric acid, which forms the major part of lemon juice, is supplied in the form of small crystals, very similar to white sugar. It is easily dissolved in water as it is needed. The strengths of both these organic acids when applied to the stone should be such that only a little effervescence occurs.

Nitric acid, together with the double sulphate of aluminium and potassium, known briefly as potash-alum, forms the resensitizing solution for zinc. The proportions used are: water 2,000 cc, nitric acid 30 cc and potash-alum 50 g. It is thought by some authorities that after the gum layer has been removed by the nitric acid, a fine deposit of pure aluminium is formed on the surface of the plate.

Oxalic acid is a highly dangerous poison, and is supplied in crystalline form. A saturated solution must be made by dissolving the acid in warm water, and to be suitable for resensitizing aluminium plates, this solution is diluted in the proportion of water 2,000 cc, saturated solution of oxalic acid 50 cc. Since there is a less dangerous alternative, this solution is not recommended.

The alternative resensitizing solution for aluminium is a mixture of: water 2,000 cc, nitric acid 140 cc, and fluorsilicic acid 230 cc.

Erasing solutions

These solutions are used for destroying the adsorbed, greasy image on the stone or plate, and to remove any mark on the non-printing areas which is taking up ink from the roller.

Caustic soda and caustic potash have many properties in common, though they are based respectively on the two metals, sodium and potassium. They are probably the most potent destroyers of grease used in lithography. Although they are supplied in solid form, they are deliquescent, that is to say they quickly take up moisture and liquefy when exposed to the atmosphere. If this process is hastened by placing the chemical in water, heat is generated in proportion to the quantity used. Therefore, like acid, these chemicals must be added to the water in small amounts. The pieces should be held in some form of tongs as they attack and dissolve human tissue on contact.

A saturated solution is made by dissolving the caustic until the water will absorb no more; it will then be in the form of a thick syrup. It is used for removing unwanted work from zinc plates, in the concentration of water 4 parts, saturated solution of caustic 1 part, though the proportions are not critical. Of the two, caustic potash is to be preferred as its action is more gentle and it is rather kinder to the hands.

Sulphuric acid is a highly corrosive liquid, and is used in its concentrated form for erasing unwanted work from aluminium plates. Aluminium reacts strongly to caustic solutions and is quickly dissolved by them. The acid should be applied with a glass rod, or a fibre glass brush.

Carbolic acid, when used in its concentrated form, will dissolve the grease from the surface of litho stone without damaging the grain. It is a very toxic substance, produced from coal tar, and should be handled with great care. It is not an acid in the normally accepted sense, being insoluble in water. It has great value because of this, as when it is being used on the stone, the gum arabic can be used as a protective barrier for work which is to remain. It is a powerful grease solvent, and can be used in conjunction with white spirit to remove caked ink which has been allowed to dry on a roller.

Acid resists

These substances are used to protect the image before etching the stone or plate. Generally, both of them are used simultaneously, though it is possible to use the resin by itself.

Resin is the solid residue which is left after the distillation of the turpentine from the liquid tapped from a certain species of pine tree. The lumps are capable of being ground into a very fine powder, and it is in this state that resin is used as the acid resist.

French chalk is finely ground magnesium silicate, in the form of a pale-grey, slippery powder; in lithography it is used in conjunction with the resin as an acid resist. It is not recommended that it be used by itself, as the water-borne etching solution tends to wash it away.

Solvents

Turpentine, an aromatic liquid, is obtained from a certain species of pine tree, usually during the summer months, when the bark is incised and the exudate collected. Genuine turpentine is now too expensive for ordinary cleaning and washing out, but forms an important constituent of washout solution.

White spirit, or turps substitute, is used for the washing out and ink cleaning operations on the plate. It can be used for cleaning ink-slabs and rollers, though paraffin is less expensive.

Washout solution is a very greasy fluid comprised mainly of asphaltum and genuine turpentine. It is used most frequently during the washing out process on plates. Being entirely spirit in composition, it is unaffected by water, and when applied to the washed out image it forms a strong, greasy base on which to build up a film of press black ink, or printing ink.

Press black, nominally, can be classed as a printing ink, as it is applied in the same way with a roller, and furthermore, proofs are taken when the image is rolled up with this ink. However, its purpose is rather more basic. The main requirement of this non-drying ink is that it should contain

a high proportion of fat which can be fed to the image to strengthen it, prior to etching the surface of the stone or plate. When the image is properly rolled up with press black, it is protected by a strong shield of grease. Press black, sufficiently diluted with turpentine, can also be used as a drawing medium instead of mixing the writing ink with turpentine. There are other uses which will be described later.

It is an ink of very stiff consistency, but it is better used without any reduction by adding either thin varnish or any other dilutant. Working it up well with a palette knife on the ink-slab, prior to rolling it out, will reduce it sufficiently for it to be rolled into a thin film.

Press black is also marketed under the name of rolling-up black.

DRAWING ON STONES AND PLATES

Firstly, it must be understood that if the surface of the stone or plate is sensitive to the action of the grease contained in lithographic crayons and ink, then it will be equally sensitive to grease from other unsuspected sources. It is disappointing to reach the rolling-up stage and to find latent images such as thumbprints adorning an otherwise pristine background, or worse, across an area on which considerable time has been spent in making a delicate and intricate drawing. Grease can reach the plate from the hair, or from the dust in the atmosphere, and will manifest itself in the form of black specks across the plate when rolling up. Fingerprints usually come from hands which are perspiring. Marks of this sort occurring on the non-printing areas of a stone do not present such a problem, as they are easily removed by scraping, or during the etching process, but for plates prevention and care in handling are better than cure. When an undrawn and ungummed stone or plate is being carried, it should always be held by the sides or edges without the hand coming into contact with the clean, working surface.

The actual mechanics of drawing a stone is largely a matter of personal choice. It is a cumbersome item to move and twist as if it were a sketchbook or drawing board, so that some sort of compromise must be adopted. Blocking up the stone under the edge furthest away from the working position is a solution if the stone is quite small, but a larger stone is best worked flat on a small table, so that it can be worked from each direction. Also, though it is more tiring, it is better to work standing up.

Drawing can also present a problem in keeping the stone clean, especially if it is a large one. Clean paper can be used to cover the part of the surface which is not being worked at the time, but this is not altogether satisfactory when a partly drawn area needs to be protected from the arm or

elbow stretching across it to work further up the stone. The work can easily be smudged.

The most efficient method of protecting the surface is to use a bridge, consisting of a short length of 3 in. × 1 in. timber with a wedge-shaped support at each end; this has the advantage of lifting the arm well clear of the stone, at the same time not obscuring any of the drawing from the constant reference which is needed.

If there is a brewery or a cooper (supposing that such a craftsman exists nowadays) in the neighbourhood, it might be possible to acquire an old barrel stave which will do the job equally well.

Should plates or stones which are in the process of being drawn have to be left for any length of time, they must be covered with a piece of clean paper, and the bridge will be found useful for keeping this clear from any wet ink or gum on the drawing.

Materials ready for drawing zinc plate. Note the registration mark at the end of the image.

When plates are being worked, the problem is less acute, as a plate can be pinned to a drawing board and rested in the lap, as long as the greatest care is taken to preserve the cleanness of the surface. With regard to this problem, when plates are unwrapped from the maker's parcel, they should be inspected, as if they have been in store for a long while, they may have become dirty. In this case, they should be thoroughly washed under clean running water, and the surface gently rubbed. Any greasy areas will throw off the water, and these must be treated with the appropriate erasing solution. The plate must be thoroughly rewashed, and then flooded with its special resensitizing solution. It is then again well rinsed under the tap and allowed to dry.

Before using the plate, and to save any unnecessary cleaning at a later stage, it is recommended that a strip about ½ in. wide all round its edge be given a coating of gum and allowed to dry. This will act as an effective barrier against dirt and grease while handling. Should the plate be one of a set for a colour print, this edge gumming should be left until the offset or the tracing has been laid, and the registration marks drawn.

The various stages between starting with a clean plate or stone, and finishing with a monochrome or colour print, can be summarized under the following headings: (1) drawing the image; (2) rolling up with press black and etching; (3) proofing in monochrome or colour. Stage (1) is carried out on the bench or table, and stages (2) and (3) take place on the press.

Notes on drawing the image

These notes apply to images which are formed by the direct drawing of the stone or plate, using crayon and gum, and the writing ink diluted with either water or turpentine. All the techniques described can be combined on the same stone or plate.

For drawn work using these media, the stone possesses one major advantage which the plate lacks: its ability to form a grease-rejecting surface after being scraped with a knife or a point remains undiminished, because its affinity for grease or gum is operative right through the stone. On a grained plate, grease-rejecting properties can only be guaranteed by the presence of gum arabic. Scraping a plate destroys the grain, so that there is no way that gum can be held in sufficient quantity. Once the plate is shiny, ink will build up.

It is possible, then, to exploit this property of stones by painting an area of writing ink and, when it is dry, working into it with a point and scraper to expose the clean stone beneath. If the stone has been grained, a controlled scraping will remove the tops of the hills of the grain and leave the ink in the hollows; this will give a negative version of chalking. The ink must be dry before scraping, as it can easily be dragged or smeared into the newly cleaned areas.

When drawing with a pen or fine brush, the ink should be of a thinner consistency than that used for drawing large areas. Some difficulty may be encountered when using the pen, as it tends to clog and requires frequent cleaning. The nibs used for drawing on the stone or plate have a softer temper than those made for writing on paper, which tend to scratch the surface if used for lithography. An exception can be made when drawing transfers, as the normal drawing nib performs quite well on this surface.

For dragged brush work, the ink needs to be even thicker, and the brush quite lightly charged. Changing the consistency of the ink and the amount on the brush will change the resulting texture. Other means of applying ink will give very individual effects, even wide variations occurring when using the same method. For instance, a small piece of sponge charged with thick ink will give a very different texture from that obtained from a sloppy ink. The pressure used in application will also change the texture.

If the posters of Toulouse-Lautrec are studied, it will be seen that he made the innovation of using a spatter of colour, which is achieved by dragging a knife across the bristles of a stiff brush, or a toothbrush, which has been charged with ink. The resulting texture depends on the consistency of the ink, the distance the brush is held from the plate and the energy with which the action is carried out. A negative effect is possible by using gum on the brush, and when that is dry, painting across the area with writing ink mixed with turpentine. This technique is known as gumming out, and is an indispensable part of the lithographer's repertoire.

It frequently happens that a white pattern is required against a black or textured background. The outline of the design being ready on the surface in the form of a red set-off tracing, or as a key drawing in offset powder, the choice has to be made whether to paint the ink, or to draw the

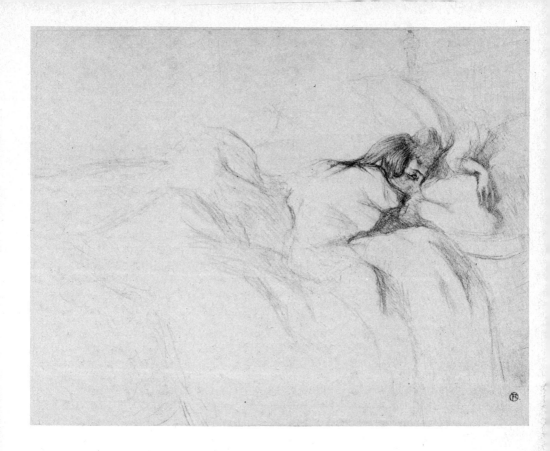

Toulouse-Lautrec, chalk-drawn
lithograph from the series 'Elles'.
Printed in burnt sienna.

chalk, round the intricate part which is to appear white in
the final print, or to adopt a more straightforward
approach. If the relevant part of the design is painted in
gum arabic and allowed to dry, this will form a grease-
resisting shield over that part of the image. It will then be
possible to chalk or paint the ink straight across the area
without fear that it will break through the gum and mark
the plate. However, it is essential in this case that the ink be
mixed with turpentine or white spirit, because if water is
used, the gum will be dissolved as the brush passes over it,
allowing the grease to penetrate through to the surface.

Staging out is a further development of this procedure.
The design can be partially realized in gum arabic – these
parts appearing white when the plate is printed – and then
other parts can be textured with chalk, or transferred
textures, and then gummed out; the full realization of the
design can be spread over several stages.

It is difficult to give any advice on using chalk, as it can
be used very satisfactorily in many differing ways, ranging
from the slow build-up of beautifully controlled tones, as
used by Bonington in the early nineteenth century, and
continued by many anonymous or little-known artists
designing music covers and fashion plates during the middle
of the century, to the elegant chalk line of Toulouse-Lautrec,
the broad treatment of Marini, and the romantic atmos-
pheric chalking of Sidney Nolan.

Traditionally, the harder chalks were used in conjunction with the finer grains obtainable on the harder stones, to work up these very delicately controlled tints, and in fact this is the only satisfactory method of achieving them. Pressing the chalk firmly on to the surface to make a dark, velvety tone will result in a more coarsely grained texture, as the chalk granules quickly build up into small hillocks which successfully prevent the addition of any more chalking in their vicinity by holding the end of the litho crayon away from the surface. For fine controlled chalking a light pressure should be used.

Conversely, there is very little purpose in trying to build up a controlled tone on a coarsely grained surface. By its nature, it demands softer chalks and a more vigorous, *alla prima* method of approach. Using these softer chalks on fine-grained surfaces with fairly light pressure will produce a soft, closely textured line.

It is possible to make areas of very fine tone by first rubbing the forefinger against a soft chalk or the stick of litho ink, and then transferring this to the grained surface by gently rubbing the finger in the required area. This can be successful on very fine-grained plates, where it appears as a wisp of tone, almost possessing wash characteristics.

Sometimes when an area of solid has been applied using the ink, the hardness of the edges can be softened by chalking them. In some ways an ink solid lacks character, and though this can be relieved by allowing the background to break through, it will retain the hard quality associated with this method. Using chalk will give a solid tint greater character, and if too much plate is showing between the closely set granules, then a fine brush sparingly charged with ink can be used to fill in the interstices until the desired quality has been attained. This method will produce a velvety solid in contrast to the hard solid of the ink.

Chalk can be used flat on its side, or sharpened to a point. This is done in the opposite way to sharpening a pencil, as the crayon is rather brittle and the end would keep breaking off. The knife is placed against one end of the chalk and pushed inwards to make a chamfer. This is continued all round the chalk until a point has been made. The trimmings should be saved as they are a means of providing interesting textures when applied to the plate floating in distilled water or turpentine. These shavings partially dissolve in the fluid to form a weak lithographic ink, while the larger particles remain suspended, only settling on to the plate as the water or spirit evaporates. When really successful, the result can be a pleasing combination of irregular specks of varied size, overlaid on a variable tone of the same colour. This mixture should not be made up until required, as in quite a short time the crayon will have completely dissolved, and the special character of the solution will be lost.

Litho ink can be applied to the stone as a thin wash, to give very pleasing delicate qualities. Whistler's lithographs of the Thames are good examples. However, these wash drawings are mainly transient, and are unable to withstand the prolonged presswork necessary in making a large edition.

The right proportion of ink to water must be discovered empirically, as the division between the wash rolling up as a solid black, or rolling up as an interesting halftone, is a fine one. These washes can be used in several different ways, but the cardinal rule, not to make more than one stroke of the brush on the same part, must be kept, otherwise the tint may well print as a solid. It cannot be guaranteed that the wash will roll up as the drawing appears on the stone. When the wash is dry, extra work can be added with chalk or pen as required.

GENERAL GUMMING-UP PROCEDURE

When the drawing is complete and dry, and to prevent any further contact between the background and the grease, the whole surface of the plate or stone must be coated with gum arabic. Although plain gum will serve the purpose reasonably well, it will do no more than act as a temporary seal for the non-image areas. If prolonged printing were undertaken at this stage the image would deteriorate fairly quickly. Because the gum is eventually removed from the surface by the continual damping and the abrasive action of the printing process itself, the finer and more closely textured parts of the drawing would spread across non-printing areas to join together and form solid tints. Therefore, to make this gumming more effective, it is usual to add a little of the appropriate etching solution to the gum. This process is then known as 'giving a first etch'.

It will be noticed that the adsorbed layer of ink acquires a greasy quality when dry, even though it was a water-borne mixture that was laid on, so that when the gum is applied, the drawing tries to throw it off. The gum collects in globules over the surface of the image, and should it be allowed to dry in this state, a narrow space surrounding each particle of ink would be found to have neither gum nor ink upon it. The reason for this is the antipathy of grease and water, so that gum, while it is still in a fluid state, will withdraw from the inked surface leaving this narrow, unprotected band. If processing continues with the plate in this condition, it will be found during proofing that the image will have spread to these areas, with a general coarsening of the work.

There are two methods of overcoming this problem. Both resin and french chalk, when dusted over the drawing,

will remove all the greasy characteristics from it. When any water-borne compound is applied to the image after it has been dusted with either of these two powders, it will be seen that the ink has lost its capacity to throw off the water, and that it can be wetted as easily as the non-printing areas, so that if the image is gummed after being dusted, the gum will desensitize the background right up to the edges of the drawing.

The second method involves no extra substance, but only a difference in the technique of gumming. The gum or gum-etch is applied in the usual manner by dabbing it firmly into the grain with a small sponge, but as it dries, it is firmly persuaded into the interstices of the drawing by gently rubbing with the palm of the hand until it has dried out sufficiently to remain in close contact with the edges of the ink, without retreating. It is possible that this method might cause some minor smudging of the image, but if the process is properly followed, and the ink was thoroughly dry before applying the gum, then this smudging will be minimal and will occur over gum that is too dry to be penetrated.

Whichever method is used, it must be stressed that all non-printing areas should receive their share of gum, especially close texture such as fine chalking or close line work, and if photographic halftone images are being used, all the spaces between the dots.

The addition of nitric acid to the gum which is used for stones, and of plate etch to the gum which is used for plates, will ensure that the non-printing areas will remain clean during the rolling-up process, and that any tendency to scum should be very much reduced.

It is always advisable to keep the film of gum as thin as possible, consistent with all the surface being covered. Only the gum which is in actual contact with the surface of the plate or stone is doing the real work of desensitizing the background areas. Over-thick gumming is positively injurious to the drawing, for as it dries it contracts, and the thickening gum sticks to the ink, especially on areas of solid. As it dries out, the gum curls back, bringing the ink with it and leaving anaemic grey patches behind. If the plate or stone is left in this condition and stored for several weeks, the damage can be permanent, especially on plates, for as we have seen, the image is not in depth as it is on the stone, but only on the surface.

Gum should never be smeared across a drawing, always dabbed; if there is any residual dampness in the drawing, it could smear across the unprotected background.

Basic gumming on stones

A solution of 50 parts of gum arabic to 1 part of nitric acid by volume is applied with a small sponge to cover the surface. This mixture should effervesce faintly a second or two after

it has been applied. Since the hardness of the stone affects its reaction to the acid (harder stones requiring a stronger solution), some adjustment in the strength may have to be made. A small drop of the mixture is applied to the edge of the stone and the reaction noted. If no effervescence occurs, a few drops of acid are added to the gum and the test repeated. This is continued until the right proportion has been obtained. This solution should be suitable for a medium-strength drawing containing chalk-work and solids.

Some authorities recommend placing the stone in a sloping position and applying gum liberally at its top end. This is allowed to drain downwards over the surface, helped with the sponge.

After gumming, the stone is left for about six hours. The following variations must be made for weaker or more delicate drawings which are composed mainly of fine chalk or pale washes.

A wash drawing must be left for at least six hours before gumming up can take place, in order that the grease can penetrate the stone and adsorption can take place. It must be gummed with a weaker solution of the gum-etch mixture, and if it is a very delicate drawing, with gum arabic only. The stone must then be left for twelve hours before processing.

Drawings which contain a large proportion of very fine or light chalkwork should also be gummed with this weaker solution.

The most reliable guide to the strength of the solution is the reaction of the stone. The mixture is tested as previously, and no effervescence should occur.

Basic gumming on plates

The gum used on plates is mixed with a small volume of the tannic acid etch. Unlike nitric acid, which actually attacks the litho stone, dissolving it and releasing carbon dioxide until all the acid has been chemically neutralized, tannic acid has no effect on the metal. Its action is mainly confined to the gum, whose brittle characteristics it changes to a leathery quality. Therefore, when used as a first etch, the amount added to the gum is not as critical, and a proportion of 10 parts of gum arabic to 1 part of etch by volume should be satisfactory for most types of work.

Zinc, because of its greater affinity for grease, and sharper grain, will naturally tend to produce a dirtier non-printing area than aluminium, so with thin wash drawings on zinc, a compromise must be made between eroding the more delicate parts of the image and keeping the background clear. If the wash is particularly thin it would be safer to gum the plate with plain gum arabic.

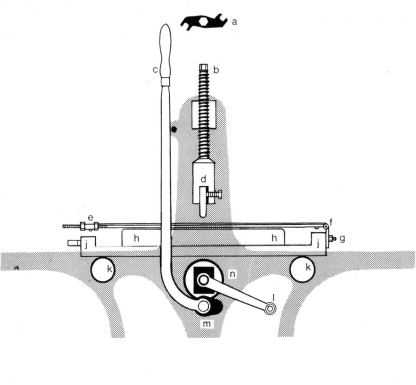

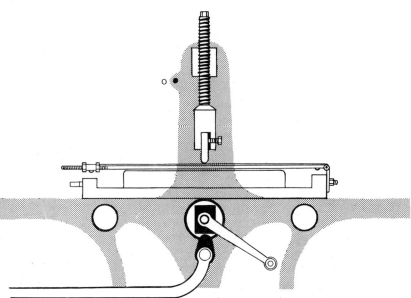

The transfer press: the upper diagram shows the press in the non-operating position, with the pressure lever up; the lower diagram shows the printing position, with the pressure lever down.
a Press spanner. *b* Pressure screw. *c* Pressure lever. *d* Scraper box and scraper. *e* Tympan securing bar and tension adjusters. *f* Tympan hinge. *g* Tympan hinge securing bolts. *h* Litho stone.
j Carriage or bed. *k* Bearing wheels. These may not be present on some presses. It is usual to have two pairs, which are used in conjunction with the runners. Where runners are absent there may be – depending on the size of the press – up to eight pairs of wheels. *l* Winding handle. *m* Cam. This operates against the bearing of the driving roller. *n* Driving roller and bearing. *o* Tympan stay guide.

5 Presses and rollers

The work on stones and plates dealt with in the previous chapter is normally accomplished on the bench, but in order that processing can continue, it is necessary to shift one's activities to the direct or transfer press.

At this stage, then, it may be as well to give a description of this press together with its method of operation.

THE TRANSFER PRESS

The transfer press, which is becoming less common, is a direct development of the simple press constructed by Senefelder. The bed on which the stone or plate rests is made from thick planks of hardwood and is strengthened with steel strips running along the underside. These also act as bearing surfaces for the roller which, when turned, carries the bed through the press on its printing stroke. The long edges of the bed have steel runners fixed to them which travel either on long flanges in the side castings of the frame, or else on bearing wheels which are fixed at intervals on the inner side of these castings.

Screwed to the front and back ends of the bed are thick transverse battens of the same width as the bed. The purpose of these, together with packing, is to anchor the stone or the plate bed. To the back batten a U-shaped iron frame is hinged, into which the tympan is fixed. This tympan is usually cut from sheet zinc or brass of about 16 gauge. It will be found that a zinc tympan will not stand the amount of punishment that can be sustained by a brass one as it stretches easily and forms cracks at points of extra tension. Brass sheeting, though initially more expensive than zinc, will outlast many zinc tympans. Plastic tympans have been recently introduced and these are said to be very efficient and long lasting.

The tympan is fixed to the hinged end of the frame by bolts which screw through it into the frame. The brass or zinc must be carefully bent round the frame and the screws inserted from underneath. These should be of such length that they do not protrude through the frame and indent the tympan. If the screws were inserted from the top, their heads would quickly ruin the scraper and the leather when the bed was going through the press.

Adjusting the pressure screw on the cross member of the transfer press.

The other end of the tympan is similarly fixed to an iron cross-piece which is looped at each end, allowing it to be loosely threaded over the open ends of the U. These ends are threaded and fitted with locknuts so that the tautness of the tympan can be adjusted. In order that stones of various thickness can be printed, the tympan hinge at the back of the bed can be raised and lowered. The tympan should only be used when it is taut.

The bed is carried by the runners under a scraper which is located about halfway along the frame. When pressure is applied, the scraper bears down through the tympan and backing papers, through the printing paper on to the stone, causing it to transfer the ink to the paper. The scraper is usually made from boxwood, about 3 in. × 1 in. section. Steel scrapers are sometimes found, but these were designed for use with a leather tympan. Several scrapers of various lengths are needed, to accommodate the different widths of stone or plates that are being used. If a long scraper is habitually used for printing small stones, its working edge and the leather which is fitted over it become depressed, so that when a large stone is being printed, an area of in-sufficient inking will be found through the middle of the proof.

The scraper box is a narrow, hollow iron box, open on its base to take the scraper, which when in position is secured by two bolts in the rear side of the box. The scraper box is free-floating except for the central adjustable pressure screw which anchors it to the cross-member. Its lateral position is preserved by the guide slots along which its ends move, and which are located in the side frames. The pressure screw is adjusted by a detachable spanner, which should also fit all the nuts and bolts used in the construction of the press.

Before fixing the scraper into the box, the interior of the box should be scraped out to remove any debris or rust which has lodged there. For efficient working, the scraper must bear solidly against the top inside surface of the box. This can be checked by painting this surface with some

thinned red printing ink. If there is only partial contact between the scraper and the box, the ink transferred to the scraper shows which parts of the boxwood must be filed down. This process is repeated until there is a satisfactory fit.

When finally fitting the scraper, the following procedure should be adopted. An accurately grained stone is placed on the bed, covered with a few sheets of paper and the tympan lowered. The scraper is inserted into the box as far as it will go and the securing screws tightened by hand. The bed is pushed into the press until the scraper is halfway along the stone. The securing screws are released so that the scraper can rest on the tympan, with its top still in the box. The pressure lever on the right or working side of the press is lowered, pushing the scraper back into the box. Without using any force, the lever is held so that the top of the scraper is in contact with the inside of the box. If necessary, the pressure screw can be adjusted so that the weight of the lever by itself will hold the scraper up. The securing screws are tightened by hand and then given not more than half a turn with the spanner. Excessive pressure with these screws will split the scraper. The scraper should always be used with the same side facing the front. This can be ensured by always locating the screw indentations to the rear of the press.

The main function of the pressure screw is to raise or lower the scraper to accommodate the various thicknesses of stone which might be used.

The method of printing using the transfer press is very simple. On the right-hand side of the press as you face it (this is known as the working side) are located the pressure lever and the winding handle. The pressure lever operates cams underneath the bearings of the roller which turns the bed through the press. When the lever is lowered, the cams raise the roller, which in turn raises the bed until the tympan is forced against the scraper leather. The roller is connected to the winding handle, but on larger and more sophisticated machines a single or double reduction gear is introduced, which makes the whole operation easier.

Printing occurs as the bed enters the press, and is completed when the scraper disengages over the front end of the plate or stone. To withdraw the bed, the pressure is released by raising the pressure lever, so that the bed can be pulled out by the handle on its front batten.

When setting up the press, it should be levelled by introducing packing underneath each foot. The press should be checked lengthwise and laterally with a spirit level. It may be found that the bed refuses to come into a horizontal plane; this is most probably caused by worn runners, as many presses in use are quite old. As long as the discrepancy is small, efficient working should be possible as the scraper and box, being free-floating, are self-adjusting and will compensate for small inaccuracies.

The feet of the press usually have holes located in them, and the wooden packing which is normally used can be secured to them with screws. Should the press be permanently moved to another position, it will have to be relevelled.

The hand-operated transfer press has a simple device to prevent the bed from overshooting the flanges and falling on the floor. On these flanges, it will be noticed that the front and rear ends are stepped to make them wider. One or two lugs are situated on the underside of the bed, and travel between the wide ends of the runners, thus preventing unwanted forward or backward movement.

Larger transfer presses can be motorized or power-assisted, but must be firmly sited on the floor. This can be accomplished by bolting the press to two lengths of timber of 6 in. × 3 in. section and about two feet longer than the base of the press. This is straightforward if the floor is of concrete, but if it is of wood, then these timbers must be placed at right-angles to the joists in order to spread the load. The excess lengths of timber should be left at the rear of the press, so that a platform can be fitted across them to take the adjustable base of the electric motor.

The motor spindle and pulley must be accurately aligned with the driving pulley on the press. All pulleys, gears and belts should be guarded for safety, and indeed, this is obligatory in schools. A coarse wire mesh supported on mild steel rods and anchored to the floor or press as necessary will serve the purpose very well. Mild steel sheeting is sometimes used, and is an additional protection against dust and dirt.

A power-assisted press will only move the bed during the printing stroke, but a fully motorized press will also return the bed when the pressure lever has been raised. To prevent over-run, this type of press has a different safety device from that used on the smaller hand-operated transfer press. If the same method were used, the continual jarring of the bed against the cast frame would very quickly cause fractures. A strap, as long as is required and about 3 in. × $\frac{1}{4}$ in. section is attached to the underframe of the press and its other end to the underside of the front end of the bed. This prevents the bed from overshooting and landing on the floor. Even with the resilience of the leather, the press will still shudder when stopping.

The older type of transfer presses are extraordinarily robust pieces of machinery, and seem to be able to function satisfactorily in the most distressing condition. However, some maintenance is essential.

The most vulnerable parts of the press are the tympan, the scraper and the leather; if these are kept in good order, the press will remain reasonably trouble-free. When a new leather has dried out after being fitted, it should be soaked with a medium-grade oil. At one time a non-drying oil of vegetable origin used to be recommended, for example

olive oil, but in view of its cost mineral oil makes an acceptable substitute. For efficient working against the tympan the friction between them must be eliminated. Grease of about the consistency of Vaseline should be generously applied to the leather and the top surface of the tympan. This grade is also satisfactory for greasing the runners. Tallow used to be used for all these purposes, but it has the disadvantage of partially drying, which makes for stiffer operation. The tympan, scraper leather and runners should be inspected frequently and cleaned. For some reason, these parts seem to attract all the small pieces of paper and grit in the studio.

The pressure screw and the other moving parts of the press are best lubricated with standard gear-box oil. If the press is geared, the gears should be greased rather than oiled. Care should be taken to avoid dropping any lubricant on to the belts, pulleys or driving roller, as this will most certainly lead to slipping when the machine is under load.

It has been found that printing is helped by introducing some resilience into the preparation of the bed. A piece of lino, or even better, a piece of thick rubber blanket is cut to bed size and laid on it. If the bed is at all uneven, it can be improved by first laying down a piece of 1-in. blockboard, cut to bed size. When a stone is to be printed, a sheet of strawboard should be laid over the rubber or lino, and the stone placed on this. In this way, the rough bottom surface of the stone will not damage the rubber, and at the same time the strawboard will prevent the stone from slipping.

When printing a plate, a polished stone which is kept for this purpose can be used as a platform, but a better method is to make a platform from about four layers of the high-density chipboard which letterpress printers use for mounting halftone blocks. The dimensions of this must be slightly narrower than the tympan, and about six inches shorter than the inside length of the bed. If the bottom layer is cut to the same length as the bed, then the platform will be well anchored and incapable of any backward or forward movement. The layers should be glued together with Cascamite or other casein glue, which is impervious to both water and spirit after it has dried. After applying the glue, the platform should be sandwiched between two large litho stones, to keep it flat, for at least forty-eight hours.

A top surface of either $\frac{1}{8}$-in. aluminium sheeting, or a plastic laminate such as Formica, would be suitable. The aluminium is fixed by $\frac{3}{4}$-in. countersunk steel screws at about 5-in. intervals round its perimeter, while the Formica should be glued, using Cascamite and drying under pressure as before.

Several sheets of backing paper are interposed between the printing paper and the tympan, which adds resilience and evens out the pressure. This backing consists of several sheets of thin card or manilla, and two of a softer paper such as newsprint. Alternatives include using a sheet of very thin

rubber between the manilla and the printing paper instead of the newsprint, or just using a piece of offset blanket by itself, with the rubber side towards the print and the cotton side towards the tympan.

During the actual printing, working normally takes place on the right-hand or working side of the press. Rolling up or other work should never be done from the front, as the pressure of leaning on the bed will cause it to enter the press, forcibly dropping the tympan on the operator's head. Most presses have a provision for a tympan stay, and this should always be used if there is a risk that this sort of accident might happen.

After the image has been rolled up, the paper to receive the image is carefully placed over it. Care should always be exercised to preserve equal margins round the image. While holding the print still, with the left hand, the backing is carefully lowered with the right hand so that none of it extends over the sides of the bed. If it does extend it must be relaid, as otherwise, during its passage through the press, it will be chewed up.

The right hand relinquishes the backing and is placed over the backing, about the middle of the print, in order to hold them steady while the left hand is withdrawn. The left hand then takes the place of the right hand, which then lowers the tympan. The left hand is then withdrawn without disturbing either the backing or the print.

This seemingly complicated ritual is soon learnt, and is necessary in order to avoid moving the print in relation to the image on the stone, when a double image will be printed. It can be readily appreciated that moving large sheets of paper or card in the air will cause enough draught to lift the print from the stone, unless it is held firmly. If it does become lifted, it will usually settle in a different position.

The bed must now be pushed sufficiently far into the press for the scraper to engage with the far end of the stone or plate platform. If the pressure screw has been adjusted correctly, the pressure lever can be pushed down until it reaches the stop. Some judgement is needed here. As the lever is lowered, it becomes more difficult to push when nearing the stop. This is caused by the cams coming into play. No great force should be required to push the lever down to its printing position, and winding the bed through the press, though an energetic pastime, should not require great strength.

Adjustment is made by the spanner on top of the pressure screw. Turning this one way or the other will raise or lower the scraper, thus increasing or decreasing the distance through which the bed can be raised by the cams. If the pressure is so great that the lever cannot be lowered without using force, it must be released, and the pressure screw re-adjusted. As this is turned, constant checking on the pressure lever should be maintained.

When the printing stroke is finished, a sudden release of

pressure will be felt as the scraper goes over the front edge of the stone. It is advisable to stop winding before this point is reached, as this sudden change of tension will distort the tympan. The extremities of the image can be marked in chalk on the side of the stone or plate platform, and these will indicate when the pressure lever can be lowered and when winding can stop.

After the bed has been withdrawn, the tympan is carefully raised sufficiently to allow the left hand to be inserted beneath it to hold down the backing papers. It is then completely raised and leaned in its upright position against the cross-member. To avoid any damage to the tympan, which would be transmitted to the print, the pressure spanner should always be left in a lateral position so that its jaws cannot puncture or dent the tympan.

Without moving the print in relation to the image, it must be inspected to see if it is satisfactory. The backing is lifted sufficiently for the left hand to be placed under it to hold the print down while the backing is being removed. The left hand is placed over the front half of the print and the right hand lifts the rear half for inspection. When this has been completed, the front half of the print is inspected in the same way. Should the printing have to be repeated, the backing is replaced and the tympan lowered, using the same ritual as previously. The most common reason for poor printing is insufficient pressure. This should be slightly increased before running the print though a second time.

Problems which may arise during printing

PROBLEM	POSSIBLE CAUSES
A dark streak running the length of the print	Extraneous matter between the scraper and the scraper leather
	Tympan has a depressed groove in it
	Long strip of paper caught between the backing papers
A light streak running the length of the print	Tympan has a ridge in it
	Scraper leather is thin at that point
The print is light down one side (more likely with a stone)	The surfaces of the stone are not parallel
	The packing on the bed of the press is uneven
The print gradually gets darker down its length (more likely with a stone)	The stone is thinner at one end (Note: both these last two problems, if it is discovered that the stone is at fault, can be cured by making a series of steps with thin paper and sticking it to the bottom of the stone, to compensate for the varying thickness. If gum arabic is

used as the adhesive, the papers can be washed off when the stone is next grained.)

General lightness of image	If the plate or stone is taking ink well, the pressure is too light; otherwise, it has been over-etched
Coarse image, show-ing spread of ink	There is too much ink on the image. Check roller and ink slab Backing has insufficient resilience The paper which is being printed is too hard and unsympathetic If the bed is difficult to wind through, the pressure is too great
Spots which are more strongly inked than the surrounding work	These are more usually associated with plates and are caused by tiny pieces of grit which have stuck to the underside of the plate, or to the platform, and have not been re-moved before fixing the plate. They form small bumps on the printing surface of the plate when it is first taken through the press. The plate must be removed and the back cleaned. Then, using a short piece of $\frac{1}{4}$-in. dowelling tapered to a blunt point, and a light hammer, these bumps can be smoothed out, work-ing from the printing side of the plate. If care is taken, the work should not suffer. If these strongly inked spots are surrounded by a clean white ring they are caused by small particles in the ink – usually dried skin
Printing well, but difficult to turn.	Usually indicates that either the runners or the tympan and scraper leather need lubricating

Generally, the sizes of transfer presses are given in terms of their bed width. For example, a crown press will take a plate or stone measuring 20 in. × 15 in., and the bed width will be in the region of 18 in.

PREPARING SCRAPERS AND SCRAPER LEATHERS

The working edge of the scraper is chamfered so that the width presented to the tympan is about $\frac{1}{4}$ in. Sometimes scrapers are supplied already shaped, but if not, this tapering can be done with a plane, the boxwood being held

in a vice. On no account must the working edge be damaged.

Scrapers are normally accurately planed when supplied, but some marginal corrections might have to be made to the working edge. It should be tested with a straightedge and the necessary smoothing performed using fine carborundum or glass paper wrapped round a flat piece of wood about 6 in. long. The end corners of the working edge should be slightly rounded to prevent them cutting into the leather after it has been fitted.

Scrapers were originally smoothed by fixing them into the scraper box, removing the tympan, and sticking a large sheet of abrasive paper to an accurately ground stone, then running this backwards and forwards through the press while the scraper was held against it by the weight of the pressure lever. However, since many of the old transfer presses now in use have very worn runners, the smoothing is more accurately performed by hand.

The scraper leather should be made from hide about $\frac{1}{4}$ in. thick, and this thickness should not vary down its length. It should be without blemishes or joins, as these will nearly always show up as streaks of light inking on the finished print.

This leather can be used in alternative shapes with alternative methods of fixing. The traditional method is to use a strip about 2 in. wide, running along the working edge of the scraper and nailed to it at each vertical end. The leather should be about 5 in. longer than the scraper. This strip is soaked in water, which causes it to stretch and at the same time temporarily makes it lose its resilience. While in this state, it can be bent to match the contour of the chamfer on the scraper.

The scraper is placed with one end upwards in a vice. One end of the wet leather is held against the scraper end, 2 in. up from its working edge. Using a fine drill, three evenly spaced holes are made through the leather into the end grain of the boxwood, penetrating not more than $\frac{1}{2}$ in. The end of the leather is then secured by three 1-in. flat-headed nails. The scraper is then reversed in the vice, and with a large pair of pliers the leather is stretched along the working edge so that it can be fixed in the same way to the other end of the scraper. The boxwood should be flanked by two pieces of wood when being held in the vice, to prevent damage from the jaws. This will also give extra room for the leather strip as it comes up through the middle of the vice.

As the leather dries out, it will contract, fitting snugly over the scraper. It is essential that the leather be tight and securely fixed; should it become loose during printing, it will go through the press partly folded, causing it permanent distortion which is reflected in the proofs as streaks of light inking.

After fixing the leather, its ends should be pared down to the same width as the scraper so that it will fit into the

scraper box. With use, the leather stretches so that occasional tightening may become necessary.

The alternatively shaped leather is more easily fitted, and with this arrangement there is no risk of it becoming detached or loose. There is the added advantage that only one scraper need be used, irrespective of the width of the plate being printed. The varied lengths of scrapers normally required is replaced by leathers of different lengths. The leather should be of a minimum width of 6 in.; the other specifications, with regard to even thickness and joins, is the same as before.

Holes are drilled at about 2-in. intervals along its length, and about $\frac{1}{2}$ in. from each edge. The leather is placed under the scraper, which is already fixed into the box. Oiled leather bootlaces are threaded through the holes on one of the edges of the leather, passed over the scraper box and threaded through the holes on the opposite side. They are then pulled tight so that the leather folds up to form a V over the scraper, and the laces are tied. With this method, the leather does not become twisted, and when it stretches with use, the laces can be easily readjusted. As wear occurs, it is possible to move the leather round so that an unworn length can be presented to the tympan. When a wider plate is being printed, it is a simple matter to replace the leather with a longer piece. The boxwood does not become indented by prolonged use with narrow plates or stones.

ROLLERS: MAINTENANCE AND USE

The hand rollers used in lithography can be divided into two main types: the nap roller, which possesses an absorbent outer covering, and is used for the proving of plates or stones in conjunction with a non-drying ink and also in the preparation of transfers, and the glazed or grained roller, which has a non-absorbent outer covering, and because of this is used for colour printing. This last type is becoming quite rare as it is being replaced by the rubber roller.

In an ideal situation, because of the superior inking powers of the nap roller, there should be one available for each colour used, and this is partially achieved in large establishments where such rollers are used for proofing specific colours on work using the tri-chromatic process.

The nap and glazed rollers are made to the same pattern, incorporating a wooden stock shaped like a large rolling pin, except that the handles cannot turn independently of the roller. When it is in use, free turning can be achieved by the use of detachable leather roller grips. Over the wooden stock are sewn several layers of thin felt, and over this, a leather sleeve is fitted which is drilled with holes round each end. These are threaded with a thick drawstring, which when pulled tight and secured by knotting, binds the leather over the ends of the roller. The leather should be a

tight fit and be unable to turn independently of the stock. For nap rollers, the suede or rough side is exposed, while for the glazed or grained roller the smooth side is used.

Rubber rollers are made by casting the rubber composition over an aluminium stock. In the main, these are lighter to handle and their performance is similar to the grained variety.

All these rollers have a diameter of about 4 in. and can be obtained in various lengths from 12 in. upwards, measured without the handles. It is now possible to obtain rubber rollers with diameters of 6 in. or larger, and in greater lengths. The purpose of these is to assist the laying down of large areas of flat tints without the formation of overlap lines or deeper inking which can arise with the use of a smaller roller. This large type is rather heavy and cumbersome to use, and because of this, the Tamarind Workshop have developed a much lighter roller using expanded polystyrene as a core.

Rollers are best stored in an enclosed rack which can support them by the handles, so preventing the distortion which will occur during prolonged periods of lying on the bench. Being enclosed, they will also be protected from grit which may become embedded in them.

The leather rollers are delivered covered with the natural biscuit-coloured hide, and will have to be worked in before being used for printing. Each type demands its own treatment.

Nap rollers

The main purpose of this type is to feed the litho image with a highly greasy ink which, in conjunction with the resin and french chalk, will resist the action of the etch used for densensitizing the non-printing areas. Therefore, it must be able to penetrate the grain of the plate or stone, and deposit the ink on every particle of the drawing. The rough side of the leather, being composed of fine hairs, is ideal for this purpose. Its grain must be positive, yet at the same time the leather itself must remain supple.

The roller is first given a good application of a non-drying oil. Olive oil, being organic, and nearest in quality to the natural oils of the leather, should be the first choice, although mineral oil of the same consistency is recommended by some authorities. This should be allowed to soak into the leather for several days. The roller is then rolled out on an ink slab, using stiff litho varnish. This should be done quite vigorously. The varnish has the effect of bringing the excess oil to the surface, which, together with the loose particles of leather which the varnish draws away, are scraped off in the direction of the nap with the side of a palette knife or a thin piece of boxwood, care being taken not to cut the leather. This process is repeated for three days, after which thin varnish is substituted, and the process continued. The rolling should

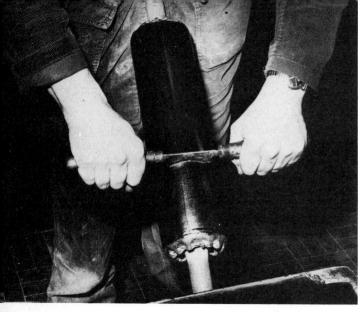

Scraping the nap roller. Note the profile-ground two-handled scraper.

be firm and vigorous. After several more days the roller should be ready for use. If transferring is to be a major activity, another roller should be prepared in the same way and reserved for this purpose.

If the grain of the roller becomes flattened, it can be restored by scraping against the nap, but this should always be followed by a final scrape with the nap.

Every six months or so, it is advisable to give the roller a holiday for a week. Prolonged use gradually fills the grain with emulsified press black. As the roller is absorbent, it is constantly taking up water from the stones and plates which mixes with the ink already on the roller, with a consequent loss of efficiency. To remove this, the surface ink is scraped in the manner described, then the roller is coated with the oil and allowed to stand for a day or two. It is then rolled out with stiff varnish as previously, which brings away the thick, emulsified ink. The roller is then worked in, using the thin varnish as before. This type of roller, properly cared for, will remain efficient for twenty or more years.

Glazed rollers

Since this type of roller may be used for various colours, its surface must be sealed to stop the penetration of colour, which would, even after cleaning, leave sufficient to adulterate the next colour to be rolled up.

The traditional method of preparing a leather roller for this type of work, is to roll it up with a good drying ink and, while the ink is still wet, roll it out on a stone that is kept well damped with water. This has the effect of glazing the surface and flattening the grain. After several days of this treatment, allowing the glazed ink to dry between each session, the roller will have been coated with a good layer of ink, impervious to any penetration by other colours. One of the umbers, which are good driers, is usually used for this purpose.

This type of roller has the disadvantage that the natural resilience of the leather has been destroyed by the glazing, so that it is not suitable for rolling up on a stone with a pronounced grain, as it cannot penetrate into the valleys of the stone to deposit ink. However, it performs quite well on polished stones and on fine-grained plates.

Grained rollers

An alternative, and better, method is to coat the roller with terebine. This substance is derived from genuine turpentine by treating it with sulphuric acid. It becomes a powerful drier and is sometimes added to inks because of this quality. After coating the roller, it is left for a day or two to dry; after smoothing with a fine-grade 'wet or dry' paper, it is ready for use. Rollers prepared in this manner preserve much of the suppleness of the original leather.

It is important that all rollers be properly cleaned after each working session. It does not take a long period of neglect for the residual ink to build up on their surfaces, reducing their efficiency, so that after printing, all the ink must be cleared. Paraffin is the cheapest and one of the most efficient solvents for this purpose. Being a non-drier, it does not completely evaporate, and leaves a fine greasy film on the roller. This acts as a protection for the surface, and prevents any residual ink from drying. If the roller is wiped over with a cloth damped with petrol immediately prior to printing, the surface grease from the paraffin will be cleared.

Rubber rollers are ready for use without any preparation, and in fact paraffin is not recommended for rubber rollers; some of them will absorb the paraffin, which progressively damages the surface of the rubber.

The transfer press discussed in this chapter is the simplest of its type available. This type of press is no longer made in its traditional form in Britain. The new presses are constructed with a roller instead of the scraper, which makes it possible for intaglio work to be carried out using the same press.

Certain American firms are making transfer presses to cater for the increasing popularity of lithographic printmaking in the States (see p. 149). Some of these presses employ a pressure lever at the top of the press, in the position usually occupied by the pressure screw. Another enterprising design uses a static bed, while the scraper moves over the stone under power. It is claimed that there is no restriction on the length of plate which can be printed.

Philip Pearlstein, 'Nudes'. Black and white lithograph, 14 in. × 20 in.

6 Proving stones and plates

In rolling out the press black both on the slab and on the plate, there is a well-defined technique to employ. After the ink has been worked by the palette or push knife into a suitable consistency, a line of ink about an inch wide is smoothed out along the length of the roller, using the palette knife so that its face is at a slight angle to the roller, to prevent any damage to the nap by cutting into it with the knife edge. A layer of ink about $\frac{1}{8}$ in. thick should be sufficient. The roller should be held loosely by the grips, preferably with the fingers curled round them, and the thumbs resting along the top. If the thumbs are curled round the grips from the underneath, it is very common for them to plough through the ink film, which can make an already potentially messy business worse.

Rolling up in press black: initial stages.

Firm pressure is used as the roller is moved towards the back of the ink-slab and returned to the front. The handles of the roller must not be gripped through the grippers when rolling.

Always when the roller has been rolled to the front end of the slab, it is lifted clear and given a slight turn, by holding one gripper loosely, and gripping the other one so that the handle beneath it can be turned. With experience, this movement is performed automatically. Its purpose is to spread the ink evenly on the slab, or on the image, because the same technique is used on the stone or plate. It can be seen that this method continually presents a new part of the roller relative to the rolled out ink film.

The roller is then lowered and rolling out resumed. It is sometimes advisable, especially if the plate or stone is a large one or is carrying a large area of solid, to disperse the ink sideways as well. The width of the film can be increased by moving the roller laterally and rolling out in that position.

It is useful to make a comparison between the area of ink needed by the image, and the area of the ink-slab, so that a sufficient area of ink can be rolled out. The film should always be as thin as possible, as coarsening of the image can result if it is built up too quickly with the ink.

Firm rolling must be used on the plate. The quality of the movement is difficult to describe, but the ink is almost 'willed' into the grain.

Rolling with the nap roller normally goes well at first, but as the process develops, it will be noticed that the ink

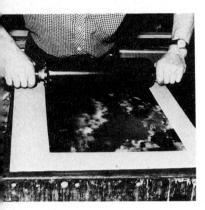
Rolling up in press black: later in the sequence.

begins to resist its transfer to the image. This is caused by the porosity of the nap roller, which absorbs water from the plate and forms a film between the ink on its surface and the image, thus preventing any contact between them. This effect is more noticeable when there is very little drawing on the plate and a large area of non-printing background. The roller will take on a very glazed appearance, and if a finger is drawn down its length, the wetness can be felt. This trouble is very common, and is dealt with by some firm and prolonged rolling on the ink-slab, which will squeeze out the water in a line at the far end of the slab.

The sound which the roller makes on the slab is a good guide to its performance. It should sound crisp, but without any hint of a tearing noise which would indicate that the layer of ink was too thick. A dull sound means that the fibres of the nap are flat and not taking up the ink, usually because of the film of damping water which has been picked up. It may also be caused by insufficiently prepared or stale press black.

While rolling up the image, continuous attention must be paid to the manner in which it is behaving, particularly in areas of fine work. At the first sign of thickening or other deterioration, rolling must be suspended, and appropriate action taken. In cases like this, the old maxim, 'When in doubt, gum up!' would apply. This will stop any further deterioration of the image, while giving a breathing space to think out the problem.

ROLLING UP AND ETCHING STONES

The stone is placed centrally on the bed of the transfer press, and covered with a sheet of clean paper. The backing papers are lowered and the tympan brought down. The bed is then pushed into the press so that the pressure can be checked and any necessary adjustments made. It is then withdrawn and the stone exposed for working.

1 Using a clean sponge and water, wash the gum from the surface. It was noted earlier that the gum penetrated into the pores of the stone. This gum remains, acting as a fine hygroscopic layer over the surface, taking up water from the damping sponge and releasing it as the stone dries out.

2 Keeping the stone wet, wash out the drawing with white spirit and a rag folded into a pad, until it appears as a dry, slightly discoloured area against the wet background.

3 Wash the stone clean with water and clean rag.

4 Take up the excess moisture with the sponge squeezed dry, so that the surface is damp only.

5 Roll up with press black, keeping the stone damp.

6 Alternately damp and roll until the image looks dark enough to print.

7 Take a proof. This is unlikely to be satisfactory. Continue damping, rolling up and taking proofs until a good black proof has been obtained.

8 Roll up again to make sure that the image is fully charged with ink.

9 Dry with drier or fan.

10 Dust the image with resin.

11 Dust the image with french chalk. Apart from acting as a resist to the etch, these remove the greasiness from the image, allowing the etch to work right up to the boundaries of the ink.

12 Wipe off the surplus resin and french chalk and clean the surface with water. (It is at this stage that alterations can most easily be made.)

13 Clean any background areas, and the edges of the stone which have become dirty or are taking ink, with a snakestone slip.

14 With strong nitric acid (water 5 parts, acid 1 part), boil the edges. A vigorous effervescence will result. On no account should this acid be allowed to touch the work.

15 Squeeze water all over the stone and clear the acid without letting it touch the work.

16 *Either* cover the surface with a solution of 10 parts of gum arabic to 1 part of nitric acid, and allow it to dry; *or* cover it with a solution of 10 parts of water to 1 part of nitric acid and leave it for one minute, then cover the stone with a pure gum solution, rubbing it well into the image area, and allow it to dry.

17 Mix and roll out the colour it is intended to use.

18 Repeat numbers 1, 2, 3 and 4.

19 Roll up in the chosen colour, taking proofs.

Etching thin washes

Because the thin drawing is so tenuously held by the stone, even the process of washing it out with turpentine will weaken it further, so the following alternative method of proving should be adopted.

1 Wash off the gum with water and clean sponge.

2 With the stone damp, roll up press black directly on to the drawn image. This will strengthen the work, allowing it better to withstand an etch.

3 Take proofs during this stage. They may well be the best ones which the stone will give.

4 As soon as the image shows signs of thickening, stop rolling.

5 Dust with resin.

6 Dust with french chalk.

7 Clean the stone with water and fan it dry.

8 Gum up the stone, rubbing it well into the image area. The stone, when dry, is then processed as for the average drawing (steps 1 to 19 above).

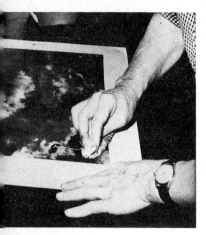

Washing out the image with white spirit and rag.

ROLLING UP AND ETCHING PLATES

The platform or stone on which the plate must be fixed is placed on the bed of the transfer press. To fix the plate, a sheet of damp newspaper the same size as the plate is smoothed on to the surface of the platform, which itself has been damped. The first journey through the press will squeeze the excess water from beneath the plate and form a near vacuum which will secure the plate firmly. It can easily be removed by lifting it straight up by a corner.

An alternative method is to secure the plate with a spot of gum arabic directly on the platform surface, but this has the disadvantage that the plate tends to slide about when being rolled up.

Care must be taken that no particles of dirt or grit are left on the platform or on the underside of the plate as these will cause small bumps on the grained side after going through the press for the first time.

Pressure is adjusted in the same manner as when using a stone.

The initial procedure for washing out the plate is opposite to that adopted for a stone. The image is first cleared without disturbing the gummed-up areas of the plate.

1 Sprinkle white spirit on to the image and gently rub with a rag; repeat until as much of the drawing as possible has been washed off. It will be found helpful to remember that the spirit will eventually accomplish this by itself, without rubbing; rubbing merely hastens the action and should never be hard or vigorous. Since the spirit has no effect on the gum, it cannot penetrate to the non-printing surface.

2 With a wet rag, wash off the gum.

3 Keeping the plate wet, continue washing out the drawing with the turpentine until it is clear. It is essential that the plate should remain wet during this operation, to avoid the spirit and ink drying on the non-printing area, and so causing scumming.

4 Wash the plate clean with water. It will be apparent that the plate is divided into two distinct areas, one dry, and the other wet.

5 Keeping the plate damp, smear washout solution over the image. It will dry almost immediately, and the image will appear as a brownish area against the grey of the plate.

6 Clean away excess washout solution with a sponge and water, leaving the plate damp.

7 Keeping the plate damp with a clean sponge, roll up in press black, taking proofs until a good black proof has been obtained. A constant watch should be kept for any deterioration of the image, and any scumming on the background.

8 When a satisfactory proof has been taken, roll up again to ensure that the image is fully charged with ink.

9 Dust the image with resin.

10 Dust the image with french chalk and wash the plate clean with water. (Any alterations and erasures of marks on the background are more easily carried out at this stage.) It will be noticed that as in the case of the stone, the image now possesses no water-rejecting properties, so while it is in this state, the etch can desensitize the non-printing areas right up to the edges of the image. Also, the tannic acid, if allowed to stay on for too long, can penetrate the resin and french chalk and destroy the adsorbed layer of grease on which the image is built up.

11 With a small sponge kept for this purpose, liberally coat all the surrounding non-printing areas with etching solution. Then, recharging the sponge, flood the image area. If it is noticed that the solution is causing the background to take on a mottled brown colour, this is an indication that the etch is too strong, and it must be cleared from the image without any delay. A suitable etching strength is 2 parts of Victory etch to 1 part of water; Atzol can also be used in the concentration recommended by the makers. The etch need not remain on the work for longer than two minutes.

12 Wash the plate thoroughly with a clean sponge.

13 Gum up, rubbing it well into the image area, as it dries, with the palm of the hand.

14 Mix and roll up the colour it is intended to use.

15 Repeat numbers 1–6.

16 Roll up in the chosen colour, taking proofs.

After etching, it sometimes happens that the non-printing area begins to take up ink. This can appear as a fine tint over the whole surface, or in a more localized way. It is generally caused by some omission in procedure – most often, rolling up over an undamped surface. If this is the case, it is quickly remedied by lightly passing the roller over the plate, and damping. Persistent scumming can be caused by omitting to gum up the surface at some vital stage, usually immediately after etching. This may be cured by putting the image back into press black and re-etching. Should the scumming extend across the image, then re-etching it becomes the first priority. If any fine drawing is involved, more radical methods of dealing with it become necessary (see below, 'Deletions and Alterations').

Occasionally, scumming is caused on the plate or on the stone by incomplete erasure of the previous work, and this will be manifested by fairly well-defined areas corresponding to the previous image. If the image area is very deeply involved, sad though it may be the stone or plate is probably beyond redemption and will have to be replaced and the design redrawn.

The strengths of the nitric acid for etching stones have been given in numerical terms and should only be considered as a guide. Before applying them to the image, it is always

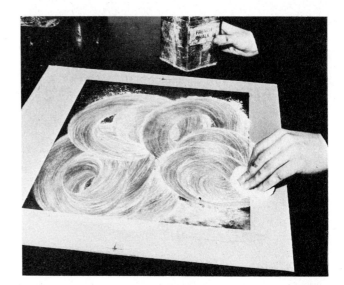

Dusting the image with french chalk prior to etching.

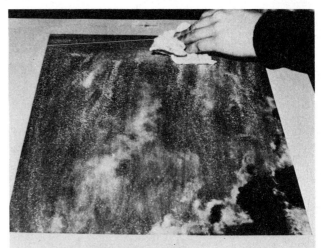

Wiping off the surplus resin and french chalk.

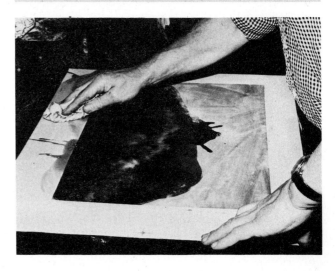

Etching the plate with Victory etch.

best to try them out on the edge of the stone. It will be found that a stronger acid is necessary on a grey, or harder, type of litho stone to produce the same degree of effervescence that a weaker acid will cause on a softer or more biscuit-coloured stone. For general etching, the solution of nitric acid in water or gum should produce a slow effervescence on application. These solutions can be applied with a small sponge, though it will tend to rot fairly quickly with the constant immersion in the weak acid. A 2-in. or 3-in. paintbrush would be better. Also, although it is unlikely that these acids will burn the hand in the strengths used, mistakes are always possible as concentrated acid, superficially, looks very like dilute acid.

DELETIONS AND ALTERATIONS

At some stage, probably sooner rather than later, it will become necessary to alter, delete, or to add extra work to the image. The marks to be deleted might be unwanted drawing on the image, or extraneous areas on the background which are printing, or accidental marks made while drawing the plate or stone. The process of deletion is closely tied up with the etching, and can be accomplished quite easily. It is usually carried out after the image has been dusted with the resin and french chalk, but before the etch has been applied. It must not be assumed that alterations are impossible to make at other times: this juncture is chosen because the action of the various resensitizing solutions in removing the gum film is more efficient before it has been reinforced with the etch.

Sometimes alterations have to be made at a later time, especially when working a multi-coloured print. It may very well be that only after proofing the fifth colour can it be decided that the first plate needs some alteration. However, after the plate has been etched, several applications of the resensitizing solution may have to be made before the surface is once again capable of adsorbing grease. Each time the solution is used, more particularly on the plate, the grain suffers, while too many applications, or using a solution which is too strong, will eventually destroy it, leaving the plate quite smooth. As the plate depends on the grain to hold the gum and water, these areas will most certainly scum.

The general process is as follows: Firstly, any unwanted work or other marks are erased. This would include any part of the image which has been ruined by persistent scumming or filling in. The surface is then resensitized, either completely if the alterations are large, or on a local basis, to remove the gum where the new work is to be added. The new work is drawn, or substituted for the old, then the plate or stone is gummed up in the normal manner.

Alterations on stones

The one unquestionable advantage which the stone has over
the plate is its capacity for being scraped with a knife without
suffering any deterioration in its ability to form a grease-
rejecting surface. Apart from being used for texturing or
drawing an image, the knife can be used to remove, by
scraping, unwanted areas of drawing or background dirt.
On the non-printing area the knife can be used quite freely,
but difficulty arises when unwanted image areas have to be
deleted and new work substituted, as the grain or polished
surface would be damaged by scraping and any extra draw-
ing would reflect this change in an obvious manner.

It has been stated in a previous chapter that the image on
a stone could only be completely removed by grinding
away the surface. To this statement there is one qualification.
When pure carbolic acid is applied to the washed-out image
on a stone, it temporarily destroys the capacity of that part
of the stone for adsorbing grease. Since the carbolic does not
affect the gum in any way, the erasing should only be per-
formed after the rest of the stone has been thinly gummed.
This will confine the action to those parts which need it.

Firstly, all but the area to be treated is coated with gum.
When this has dried, the image or other area to be erased is
washed out with turpentine. A little carbolic is applied and
gently rubbed with a blunt-pointed stick. If desired, a few
drops of petrol can be incorporated with the carbolic. The
stone is then thoroughly washed with water to clear the
carbolic and gum and, when dry, is dusted with resin and
french chalk. If no extra drawing is to be made in these
erased areas, they are resensitized with the citric or acetic
acid solutions before applying the gum-etch solution. The
stone must be washed between resensitizing and etching.
If extra work is planned, these areas are resensitized,
thoroughly washed and allowed to dry. The new drawing
can then be added.

Although the pattern of the previous work will remain as
a discoloured area, it should not cause any trouble by taking
ink.

After the drawing is complete and dry, gum, or gum-etch,
should be applied. Washing out, rolling up and etching in the
normal way can follow.

Alterations on plates

The image, lying only on the surface of the plate, is more
vulnerable than the image on stone, and this makes it easier
to erase. Although the use of a snakestone slip is sometimes
advised, to erase extraneous marks and persistent scumming
from the non-printing areas, any action which harms the
grain should be regarded circumspectly. The grain is more
important on plates as it is the vehicle for holding water,
and if it is damaged, then scumming is probable.

Any unwanted mark that is printing should be capable of complete erasure by chemical means.

Alterations on zinc plates

The plate should be washed with water to clear it of gum. If the area of unwanted work is extensive, the ink in these parts should be washed out with turpentine. This will make the action of the caustic more rapid when it is applied.

The plate is then cleaned with water and thoroughly dried. This must be emphasized, as applying caustic to a damp plate will allow the chemical to spread quickly to other areas where it is not needed, causing damage to the drawing. It is sometimes advised that the parts to be erased should be dusted with resin and french chalk. This certainly helps the caustic to penetrate more quickly through the greasy image to the zinc, but it does carry the risk of spreading the chemical. However, if the area to be treated is isolated by non-printing background, which is dry, the danger is remote.

The most efficient tools for applying the solution can be made in the studio. These should consist of a range of sticks varying in size, from a matchstick, up to wood of section $\frac{1}{2}$ in. $\times \frac{1}{4}$ in. The ends of the smaller pieces can be tapered to a point, while the larger widths can be given a wedge-shaped end. If they are well charred in a flame, the wood becomes slightly hardened, and at the same time the charcoal which is formed on the outside makes a very fine abrasive for persuading the caustic into the image without damaging the grain of the plate. These sticks are dipped into the caustic solution and applied to the image. With the small sticks, it is possible to erase very small spots of ink without the adjacent work being affected.

Removing unwanted image from aluminium plate, using sulphuric acid and burnt matchstick.

Depending on its strength, the caustic is left on for a minute or two and then sponged with plenty of water. Further applications must be made, if necessary, after the water has evaporated. This can be a prolonged operation, especially if there are several areas to be treated. To save wasting time, these areas can be treated in rotation, so that while one area is receiving the attention of the caustic, another is drying after being sponged, and a third is having the caustic applied.

The sponges for this work should be thoroughly cleaned after use, to prevent the caustic from rotting them. They should never be used as etching or damping sponges, as caustic will inevitably be transferred to a perfectly sound image on another plate.

When the erasing is complete, the plate is washed clean and the areas which have been treated are resensitized with the nitric acid/potash alum solution. It is then washed clean. If no additions are contemplated, it is gummed up. Should extra drawing be required, it is added after the plate has been washed following the application of the resensitizing solution.

It is normal practice to dust the existing image with french chalk before applying the resensitizing solution. If this was not done before erasing any work, it should be carried out after the plate has been cleared of the caustic, washed, and allowed to dry.

When resensitizing for the addition of work, it is always best to resensitize a larger area than that actually required; just dropping the solution on the plate for the addition of a few spots of ink is not generally successful. It is possible that some of the large area of gum which surrounds these small areas bleeds into them and partially desensitizes them, being carried by the water which is used to clear the resensitizing solution.

Sometimes it is even good policy to resensitize the whole plate. In this case, after clearing the plate of caustic, or, if no erasures have been made, of gum, it is wetted under the tap. After the surplus water has drained off, the nitric/potash alum solution, in its working concentration, is poured directly from the bottle onto one end of the plate. The plate is then tilted so that the solution can quickly spread to the entire surface. (It may be noticed that the zinc darkens after the application; this is a sign that the plate has responded.) The plate is then washed clean, and after drying, is ready to receive the new drawing.

More localized resensitizing can be accomplished by liberally painting on the solution with a water-colour wash brush, not forgetting to rinse it after use.

It is normally considered that any drawing added after resensitizing a plate is held rather more tenuously than the original, and for this reason it is not always advisable to give the standard etch. After the drawing is complete and dry, it can be gummed with the gum etch. Only when rolling up

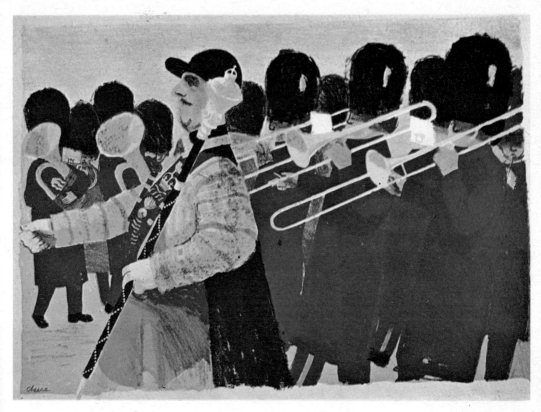

Bernard Cheese, 'Guards Band'. Coronation lithograph, 1953.

and proofing are taking place can a decision on a full etch be made, based on the quality and appearance of the proof or on the way the added work is taking ink.

Alterations on aluminium

The general procedure for these plates is very similar to that adopted for zinc, with the exception that the solutions are made up from different chemicals.

Aluminium creates its own problems, being more porous than zinc. Because of this, the metal holds the image more firmly, and also the grease-rejecting gum film. Therefore the erasure and addition of work can present greater difficulties than those encountered when working on zinc. However, these properties of aluminium generally ensure a plate that is cleaner-working than zinc, and the incidence of scumming is not so frequent.

Commercially produced etching and resensitizing solutions

For the lithographer who prefers to work with readymade solutions, there are several excellent compounds available. *Atzol* is a gum-gallic etch, based on tannic acid and gum arabic, which has been marketed for many years. It can be used on both zinc and aluminium, and in the roles of a first etch or a main etch.

More recently introduced products are *Agum O* and *Agum Z*. These provide standard gumming and etching procedures for both metals, while Agum O can also be used on stones. The initial drawing is gummed up with Agum O, and this is allowed to dry. The image is washed out in the usual way over the dry gum. The plate is then washed clean and rolling up proceeds. On the attainment of a good proof, the image is dusted with resin and then gummed with Agum Z. This is left for half an hour before washing out and proofing in colour. Neither gum arabic nor any other etch should be used in conjunction with these solutions.

Prepasol is a commercially made solution for resensitizing both zinc and aluminium plates, based on the nitric acid/ potash alum formula. *Erasol* is a twin product for deleting work and is based on caustic potash.

(Opposite)
Michael Ayrton, illustration from *Poems of Death*, an anthology published by Frederick Muller in 1945.

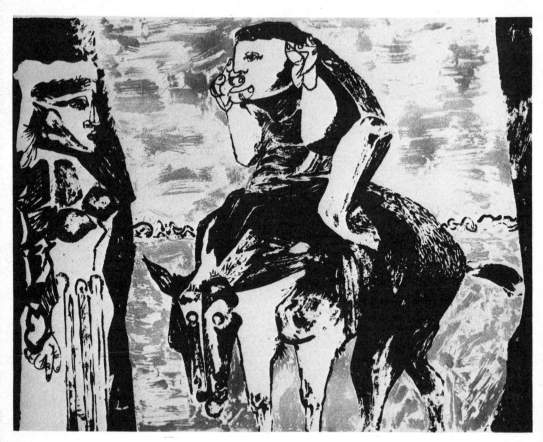

Robert Colquhoun, 'Mysterious figures'. Lithograph in two colours. The black drawing was transferred to the stone, and the buff was drawn directly on the stone. Lithographed at the Curwen Studio.

7 Registering and drawing colour plates

It will be appreciated that the colours cannot be drawn on each plate, willy-nilly, in the hope that somehow all will come right on the final print, and it is here that one of the major disciplines of the craft must be exercised: ensuring that each colour prints true in its accorded place on the finished proof.

There are several methods of achieving registration, but the success of them all depends upon the care of the artist. If one's natural mode of expression is free, some disparity in the registration may be encouraged, to enhance the spontaneity of the print, but if one's work is precise, then the registration should be equally so. This accuracy depends mainly on the key drawing and on the care that is put into the press work.

The simplest method of registering two or more plates so that one can be printed over the other in its proper place involves the use of a complete tracing of the original design. This tracing should indicate, using line only, the major changes of colour and the arrangement of the various elements. To this, about 2 in. out from the centre of each of the shorter dimensions of the image area, a cross should be carefully added. Its distance from the image can depend on the size of plate and paper being used, so that its distance from the image might be more. If possible, it should never be less than 2 in. in order that a good margin can be preserved.

This tracing is traced down to all the plates which are needed to complete the design, using red set-off paper. This is a non-greasy substitute for carbon paper, made especially for this purpose. If carbon paper were used, it would make a printable image. All that is required is a temporary guide for drawing the various colours.

During the tracing procedure, the paper should be securely taped to the back of the plate to stop any movement, which would interfere with registration. It is better to trace all the plates at one time, rather than when they are required for drawing.

When the tracings are complete, all the registration crosses must be first drawn in, as finely as possible, using litho ink. When these are dry, the edges of the plate right up to the image area should be coated with gum-etch. This will ensure that the margins will keep clean while handling and during the rolling-up process.

When making key drawings or tracings from an original design, it must be decided early in the proceedings whether the offset press or the transfer press will be used for making the finished proofs, as provision must be made for any lateral reversal of the image. It should be remembered that plates used on the offset press must be in their correct phase.

It is good practice when tracing this key to arrange that the image is in the same relationship to the edges on each plate. After tracing the original design and adding the registration crosses, the tracing paper can be trimmed on two adjacent sides, so that when these are orientated to the equivalent sides of each plate, the image will automatically be placed in the centre. This will ensure clean margins of good proportion. It will also facilitate registration on the offset press should it be used, especially if the image is lying square to the edges of the plate. If there is too much discrepancy from the square, it is possible that the range of adjustment of the front and side lays on the press would be insufficient. This squareness to the plate is critical if the work is later to be incorporated with type, as registration on letterpress machines is achieved by the right-angle of the paper.

This general method of using a key tracing possesses certain built-in risks. The tracing has to be traced down as many times as there are plates to be drawn. Each time, it will expand a little. Inaccuracies can also be introduced by movement of the paper in relation to the plate.

An alternative would be to make a wasted key. A tracing is made of the original design on normal tracing paper. This is traced down to one plate, using a ball point pen and carbon paper. This will give a fine printable line on the plate. When the tracing is complete, registration crosses are drawn in at each end of the image, leaving a margin as before. After gumming and washing out, the plate can be rolled up with press black and proofs taken on the rough side of MG paper.

As many proofs should be taken as there are plates, together with a few more which can be used to check registration when proofing the colours. The press black should be sparingly rolled as its purpose is to act as an adhesive for the offset powder with which they will be dusted.

When taking the proofs, the plate must be dry before the MG paper is laid down, in order to prevent any expansion of the paper due to absorbing moisture. All paper, being of vegetable origin, is hygroscopic, and the expansion caused by this can visibly alter the positions of the registration marks. The larger the paper, the more will be the error.

After these proofs have been taken, they should be allowed to stand for an hour before dusting them with offset powder. This powder is non-greasy, violet in colour, and sticks to all the printed lines on the paper. When one of these proofs is laid on to a clean plate and run through the press, the powder is transferred to its surface, producing an identical image to the original, but of course violet in

colour and non-greasy. Should the original prints have been too generously inked, this will penetrate the offset powder to make a printable mark on the new plate.

The rough side of MG paper is most suitable for these 'offsets', because the offset powder does not stick to the un-inked areas as much as it does on most papers. Enamelled papers are a good substitute but they are more expensive. The method of dusting is as follows. A small pile of powder is poured from the tin on to the middle of the proof, and the paper is then held so that its shorter ends are almost touching. These are alternately raised and lowered in a seesaw manner which makes the powder extend across the proof in a narrow band. The paper is then opened out slightly and the movements continued so that the offset powder is agitated down to coat the registration mark at one end. The other end is then treated similarly. Surplus powder is collected and poured back into the tin; flicking the paper from the back will release any powder which has become stuck to a non-printing area. Alternatively, a little silver sand can be poured on to the print after the image has been dusted; shaking this over the surface will scour the unwanted powder away. If the offset powder supplied is very gritty, it should be pounded in a mortar, with a pestle, as it will not give very satisfactory results otherwise. The supply of offset powder has become rather uncertain, as its use in commercial printing has ceased, but other powders have been tried; jewellers' rouge, red ochre powder and pottery pigments give satisfactory results.

It is sometimes advisable to damp the plate before laying down the offset, especially if it is composed of very fine work. If water were used for damping, the offset would expand, throwing the registration out. It will be found that methylated spirits is a good solution to use, as it has no effect on the stability of the paper and readily brings the offset powder into suspension, making a very clear and crisp outline. Because of its speed of evaporation, no time should be wasted in this procedure. Too much spirit will cause drastic spreading of the image, rendering it unfit to use. However, washing the plate under the tap will clean it so that it can be used again.

It is advisable to damp the plate well with the spirit and hold the offset in readiness to lay it down when sufficient spirit has evaporated.

When laying the offsets, the two trimmed edges should be placed coincident with the equivalent edges of the plate. A sheet of clean paper is laid over, and the backing and tympan lowered, taking care not to disturb the position of the offset. It is run through the press once, and the pressure released. Again, without disturbing its position, it must be inspected for satisfactory transfer of the violet image. If it is not satisfactory it must be put through the press once more, with increased pressure. It must be realized that there is no ink on the plate which will hold the paper

down, so that extra care must be exercised when moving the tympan and backing papers.

Some lithographers work spontaneously, drawing directly on to the plate, guided by an idea that exists only in their minds. When it is considered that enough work has been drawn on to the first plate, registration marks are added and the plate gummed.

Rolling up proceeds, and proofs are taken on the rough side of MG paper to provide offsets to lay down on the ensuing plates; when working in this manner it is possible to include some indication in line on the first plate to be drawn and extra to the image, which will act as a key for drawing the other plates. Again, during the rolling up with press black, proofs are taken to act as offsets: once these have been successfully laid to the remaining plates, the extra lines can be erased with the appropriate solution and the plate etched in the normal way.

As a general rule, it is better to prepare all the plates needed for a colour print at the same time. That is, each plate should be ready to draw, having on it the offset, the registration marks drawn in litho ink, and the edges gummed. When they are dry they are wrapped in clean paper so that they can be used as they are required.

When the first colour plate is drawn without the addition of extra guide lines, the offset taken from this plate is used as a basis for working the second plate. It will be apparent that this method of working involves great self-confidence and considerable experimentation. It also implies a great measure of freedom in the design, as registration cannot be very exact. After the second colour has been printed over the first, it is possible to make a tracing of the image and add to it on paper so that this can be traced down to the third plate by means of the set-off paper. After the third plate has been printed the tracing can again be augmented, and this sequence is followed until the print is complete. It must not be forgotten that registration marks are essential and must be drawn in on every plate.

In making a colour lithograph it is normal practice to draw one plate at a time, process it, and then proof it in colour before proceeding to the next plate. By this means, the lithographer can see the design taking shape and if he wants, make any alterations in the drawing. Thus the act of lithography remains a creative process right through the sequence of plates, rather than a sterile reproduction of a paper design which has been completely realized.

When the first plate has been etched it is printed in colour. The approach should be experimental, so that the colour can be changed at will. The guiding factor is, of course, the quality of the image which is in the artist's mind. The second plate is drawn with reference to the first, considering possible overprinting, and how much the image needs to be developed at this stage. There might be reference to an original rough design which exists on paper. As this

Henry Moore, lithograph from the 'Shelter Sketch Book', 1940–42.
Lithograph date 1966–67. 14½ in. × 12¼ in.

sequence of working proceeds, this design will diminish in importance and the print itself will exert a greater influence on its future development.

It is only when the second colour is to be printed that the use of registration marks can be fully appreciated. It can be seen that if the crosses which have been printed on to the paper with the first colour are laid on to the crosses which have been drawn on the second plate, and if they and the image have been drawn in accurate relation to one another, then the second plate image should fall directly over the image printed from the first plate.

To achieve this, two methods are recommended. In the first, a triangle is cut out of the paper, in one of the angles of each of the two registration marks. Since it is better always to work in the same sequence, it is good practice to cut out the equivalent angle at each end of the image, and it is usual, though not essential to use one of the outside angles of the crosses. If the paper is now laid on to the second plate so that these triangles coincide with the corresponding angles of this plate, then the colour must be in close registration.

Sighting one of the plate crosses through the corresponding triangle, lay that end in position and hold it firmly with the thumb. The other end must be held away from the plate to avoid premature inking, while the second cross is sighted in the same manner. When the print is down, it must be held firmly while the backing is lowered and then the tympan.

A variation of this method is the use of square windows. In this case, the lines of the crosses need to be long enough so that a square window can be cut from their middle, leaving sufficient length of the four lines of the cross to complete the cross, partly on the plate and partly on the paper, when the print is laid down to the next plate.

The alternative method involves the use of registration needles. These are easily made in the studio by snapping off the points of two darning needles and carefully pushing the eyes into the ends of two 2-in. lengths of $\frac{1}{4}$-in. dowelling rod. The broken ends are ground to a stubby point on an oilstone.

These needles are pushed through the registration crosses at the intersection of the two lines, from the back of the proof, and orientated to the corresponding points on the plate. To prevent premature inking, the paper must be kept taut, and supported at the ends by the first two fingers of each hand curling under the sheet, while the thumbs press down on top of the dowelling. When both needles are properly positioned, the fingers are removed, allowing the paper to drop down to the plate. The paper is held firmly while the backing and tympan are lowered, and printing can then take place. It is helpful with this method to dent the plates at the intersections of the crosses, with a light tap of a hammer and nail in order to assist with the location of the needles.

Should any discrepancy in the position of the registration marks be discovered during printing, the error can be

rectified by using the following method. With the plate dry, a proof is taken on transparent paper (a sheet of tracing paper will do), which is laid over each of the prints so that the image is in exact registration. Using a registering needle, puncture the transparent paper through the intersections of the crosses, and pierce the proof underneath. This must be carried out on all proofs which may be suspect. The new crosses can be drawn through the puncture mark and, if required, new triangles can be cut.

If one of the plates in a sequence is at fault, a proof is taken from one plate in the series whose registration is known to be correct, using tracing paper as before. The image on the suspect plate is dusted with french chalk and the proof on the tracing paper is laid over it so that it is in exact registration. The plate is then indented with a hammer and nail through the intersections of the crosses on the tracing paper. If the crosses are completed with waterproof drawing ink, provided the plate is dry when they are drawn it is possible to complete the series without their becoming erased. However, should the plate be the first one to be printed, then the registration marks must be able to print on to the proofs in order to register the rest of the colours in the sequence. Some local resensitizing would then be necessary, followed by drawing in the new marks through the indentations with litho ink. They will not have to be etched.

DRAWING PLATES FOR COLOUR

When working the various colour plates that will eventually make up the complete design, certain fundamentals must be understood in order to reduce the chances of having to make later corrections. Generally, the original design should mainly be regarded as a starting point for a period of creative activity which culminates with the final proof. Unfortunately, it is too often regarded as a time when previously decided areas of colour and texture are merely drawn as a necessary prelude to printing.

It is impossible, with the various media available for working out the design of a lithograph on paper, adequately to represent the unlimited nuances which the medium is capable of giving. They can be approximated, but not imitated. So many variations are possible when overprinting, that in many instances the result is unpredictable. So much depends on the relative opacity of the inks and the colours which are adjacent to them when they have been printed. Papers of different-toned whites also have a marked effect on the final appearance of the image.

From the way in which our vision operates we know that any colour at which we are looking is always accompanied by its complementary, and the strength of this implied colour depends on the intensity of the colour which actually is present. In making colour images the painter is continually

Norwyn Watkins, 'The Cyclist',
1973.

assessing this phenomenon and making any necessary adjustments to his work. The position is complicated for the lithographer in that he is always drawing with black pigment, so that he is fortunate if he is endowed with well-developed capacity for foresight. Happily, this can be gained with experience.

Most beginners in the craft encounter some difficulty in relating the tone of the black ink to the tone of the colour in which the plate will eventually be printed, particularly with yellows and other pale tints. The black drawing on the plate is sometimes so delicate that it is hardly visible. If the drawing ink and chalk are regarded in the same way as the gouge or chisel in woodcutting, or the needle for etching, that is, as a means of separating the printing and non-printing areas, this problem can be reduced. Also, there is little purpose in using delicate chalking or other fine texture on a plate which

will be printed in a pale tone, as marks which may appear quite plainly in black on the plate might be almost invisible when printed in a pale cream.

The drawing is made on a plate that is clean, except for the outlines of the key drawing showing against the surface either in violet or red. Sometimes the colour is drawn to overlap the various shapes, flowing in and out of the forms: at other times the colours may only butt with one another. In this last case, there are several criteria which operate. It is almost impossible to arrange a colour to stop at a definite line on one plate, while on the next, the colour is drawn to continue where the previous one stopped. This might be possible if all the divisions in the print were vertical, or parallel to one another in some other direction, so that when printing, if gaps appeared between the colours, the paper could be moved in one direction to compensate, and to close every gap at the same time. However, if this were done when the divisions between the colours were in random directions, closing gaps between some of them would mean making them wider on the rest.

To solve this problem, the colours must overlap to some extent, the amount depending on the scale of the print. A $\frac{1}{4}$-in. overlap may be acceptable on a four-sheet poster, but not for a book illustration. For the average lithograph, the width that is normally used is the width of the line on the key drawing which separates the two areas of colour. So on one plate the colour to the left of the line extends across it, while on the next plate the colour to the right of the line must also extend across it. The band is so narrow that any additive tonal result of this overprinting is not obtrusive.

Since the white background of the paper has always been considered an important colour in printmaking, and most lithographers control its presence as carefully as they control the other colours, any unwanted white lines or areas can have a damaging effect on the final image.

Normally, the drawing and proofing of coloured plates is pursued in sequence. Initially, the original design will exercise some control over the drawing of the first plate, but after this has been proofed in colour, the second plate will be drawn with reference to the first. When this second plate is proofed over the first colour, then the third and following plates can be worked with more certainty as the direction in which the print is moving becomes more obvious. Modifications in colour, tone and texture can be made within the limitations of the key.

If a key drawing is not being used, then modifications of a more radical nature are possible.

Lowell Nesbitt, 'Tulip'. Lithograph in purple and white, $26\frac{3}{4}$ in. × $18\frac{1}{2}$ in.

8 Printing inks and additives

Printing inks are compounded in a similar way to all paints and contain many of the same pigments. These pigments must be suspended in a durable medium which will seal them from the destructive action of the atmosphere and its pollutants, as well as anchoring them to the surface on which they have been applied. As paints differ according to the use for which they have been designed, so do printing inks. The main difference between paints and inks is that paints, being intended for application with a brush, possess minimal viscosity, while printing inks, because they have to be applied with a roller in a thin film which must be stable and resistant to spreading, possess considerable viscosity. This varies with the purpose of the ink, those meant for letterpress printing having the least while those designed for direct lithographic work possess the most. The viscosity of offset rotary inks lies somewhere in between.

Unfortunately for the artist, these direct inks are becoming more difficult to obtain. Although they are the inks most suited to his purpose, direct lithography in a commercial sense is virtually defunct, so that they are no longer manufactured in quantity. Therefore, a knowledge of the compounding of ink, and the means whereby available products can be adapted to his use, is valuable to the printmaker.

Lithographic ink can comprise five main types of ingredient: the vehicle, the pigment, driers, drying retarders, and additives to modify viscosity, gloss and body. These will be discussed in order, but there is a degree of overlap in function between certain of these materials.

VEHICLES

The traditional medium used in lithographic printing inks has been linseed oil varnish. However, as a result of experiments carried out with synthetic resins and gums since the war, most offset inks now contain these, either wholly or in part, in their make-up. Offset inks are formulated to cope with the very high speeds of modern offset printing, and their synthetic additives control viscosity, enhance drying capabilities and give stability under the extreme conditions of heat and movement associated with this type of work.

Linseed oil in its raw state, as used in the compounding of artists' oil colour, is a greasy liquid with little viscosity. Controlled heating and boiling increase the viscosity and eliminate much of the grease, and at the same time improve its drying properties. During this process, the oil darkens in colour and this change is directly proportional to the period the process lasts, though with modern methods this change is reduced to a minimum. Its viscosity also increases with the length of the treatment. The various grades of varnish (thin, medium and thick) are drawn from the vat at intervals as their particular grade of viscosity is reached, the thinnest being tapped after about an hour, and the thickest after it has boiled for up to 24 hours. The thinnest varnish is almost colourless, while the thickest possesses a warm golden colour. This coloration is sufficiently slight for most pigments mixed with it to be unaffected.

Linseed oil varnishes become yellow when deprived of sunlight. This has always proved a difficult problem for colour-makers, as prolonged sunlight destroys the permanence of many pigments mixed with this vehicle.

The vehicle, be it resin-, alkyd- or linseed-based, dries in two or three ways, dependent on the presence of volatile solvents. If these are present, then at first evaporation will occur. After these solvents have left the ink, it will dry partly by absorption into the paper, followed by oxidation to form a polymer. Unadulterated linseed oil varnishes dry only by absorption and oxidation.

These processes are influenced by the nature of the paper which is being printed and also by the available oxygen supply. If there is plenty of oxygen present, then drying will be hastened, but if the ink has to rely on obtaining it from the atmosphere, drying will be slower. Warm or moving air assists drying while cold, still and humid conditions retard it.

Absorption into the paper is controlled by the paper's structure. Hot-pressed and sized papers are less absorbent than unsized and Antique papers.

Commercial printing, because of the speeds involved, does not rely on atmospheric drying. In any case, it would be impossible for the air to penetrate the piles of prints as they are delivered from the press. Offset inks therefore have compounded with them their own supply of oxygen in the form of 'driers'. Although these inks act efficiently in the situations for which they were made, they can cause trouble in the context of hand or direct lithography.

To be on the safe side, the lithographer should assume that no ink is ready for the press in the condition in which it comes from the tin. Generally, for hand printing, modifications to its consistency would be a normal procedure, apart from any modification to its colour.

Although the pigment is ground into the varnish during ink manufacture, supplies of varnish should always be available in the studio: these should be in thin, medium and

thick grades. For modifying the factory product, these varnishes can be used in discreet quantities, bearing in mind that thin varnish used to reduce the viscosity of an ink will tend to encourage scumming because of its grease content, while the thick varnish, when used for adding viscosity to an ink, will tend to produce a gloss. Further additives, or alternative methods, would have to be used to avoid these troubles.

The quick-drying inks normally used for offset printing can also be a problem, especially when printing a multi-plate job relying on extensive overprinting. It was noticed earlier that ink dries partly by being absorbed into the paper. Most printmakers will have had the experience of the first colour in the series going down with a beautifully matt surface, but as proofing continues, a gloss builds up and by the time the last colour has been printed, a hard, shiny surface has resulted.

The trouble would have been initiated by the very efficient drying of the first colour, which sealed the pores of the paper so that no more of the vehicle could penetrate, and forced all the subsequent colours to dry on the surface. The pigment in each layer tends to sink to the bottom of its particular film, leaving the vehicle to dry over it as a gloss varnish.

Another difficulty sometimes encountered may occur when inks of different drying rates are mixed, as the drying rate of the resultant colour will be unpredictable. This problem can become acute in communal workshops when planning the future use of presses, as once a multi-colour print has been started the timing sequence is governed by the drying time of the inks. If there is a queue waiting to use the presses – as there usually is in this type of studio – forward planning can be difficult.

PIGMENTS

Litho inks are stiffer-bodied than the equivalent letterpress inks, as they carry a higher proportion of pigment in relation to the vehicle. This is especially true of direct litho inks.

The pigments can be classified in several different ways. They can be grouped according to their derivation, their method of manufacture, or to their position in the spectrum. They can also be categorized according to their action as drying agents, their opacity or their permanence. For the purposes of this chapter, it would be better to deal with them by combining the first two groups, discussing their other properties as it becomes necessary.

Pigments are obtained in three basic ways: from the earth, by chemical action, or by condensing the fumes of burning substances. Earth colours and some fume pigments have been used since man first began to draw. Of all the colours available to the artist, they are the most permanent and paintings in

which they have been used have already existed for many thousands of years without serious impairment of their hue. Furthermore, they are among the cheapest. Unfortunately, not all earth pigments are suitable for lithography, as however finely they have been ground, they always remain gritty. Pigments intended for this use are more finely ground than those used in any other form of printing, and possibly this fineness is only exceeded by the pigments used in artists' oil colours.

All pigments have some abrasive effect on the printing surface, and the litho image, more particularly the plate image, being only a microscopic layer of adsorbed grease, is more vulnerable than any relief surface.

The main earth colours consist of the ochres, siennas, the umbers and some reds. The siennas are the most suited to lithography; the ochres, usually being associated with clay deposits, contain minute particles of grit, while the umbers are naturally gritty pigments.

All of these substances are based on various oxides of iron. The simplest of these oxides (Fe_2O_3) provides the colours Indian red and purple brown. In its hydrated form ($Fe_2O_33H_2O$) it strangely gives us yellow ochre and raw umber; when these oxides are roasted, the 'burnt' versions of these colours are formed. The presence of alumina, silica and carbon as impurities causes the variation of the ochres and siennas, while the dark tone of the umbers is caused by the presence of manganese dioxide or black manganese.

The natural pigments go through a crushing process followed by levigation in tanks of water, where the various particles fall out of suspension at intervals, depending on their size.

Synthetic forms of these colours have been made for some years, and because of their purity and enhanced pigmentation they are more economical in use, even though more expensive. They belong to the group of chemically produced pigments, and are usually extended by the addition of alumina or other inert material. The synthetic ochres provide a wider range of yellows than is possible with the natural product.

The oxides are made by the controlled heating of copperas (ferrous sulphate). Since the colour-modifying impurities are absent, the quality of hue is regulated by the length of time for which the heating is prolonged and the temperature which is reached.

The synthetic ochres are produced in a more complex manner, involving the injection of finely powdered metallic iron and compressed air into a solution of heated ferrous sulphate.

Since both the synthetic and natural earth colours are oxides, they transmit good drying power to the linseed oil vehicle. The opacity of these pigments ranges from the moderately transparent raw sienna to the moderately opaque burnt sienna and Indian red.

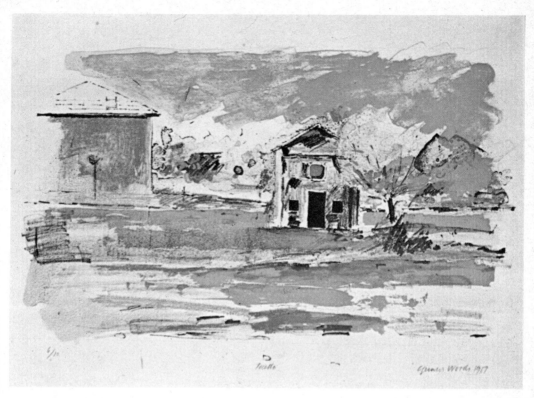

Gerald Woods, 'Pecetto', 1967. 18 in. × 12 in. Colours in order of
printing: dark brown, ochre, green, opaque light blue.

(Opposite)
Michael Ayrton, illustration from
Poems of Death, an anthology
published by Frederick Muller in
1945.

p. 86

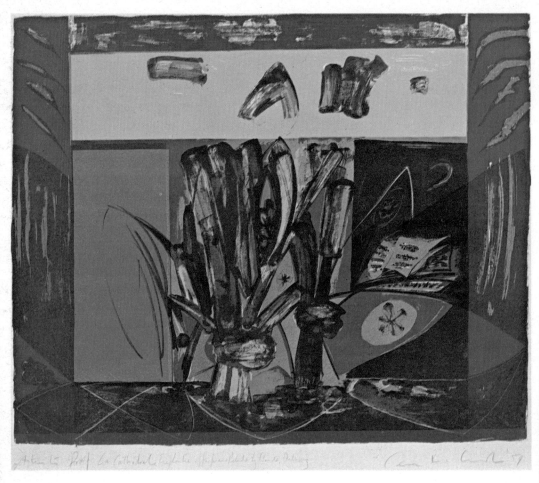

Ceri Richards, 'La Cathédrale Engloutie II', from the Hammerklavier Suite.

Some chemically produced colours are formed by precipitation, i.e. when two or more aqueous solutions of specific chemicals are mixed together. Among these are the chrome colours, which form the group of yellows most widely used in lithography. The range extends from a pale primrose to an orange vermilion and these are among the most opaque inks available to the printmaker.

When solutions of potassium bichromate, lead acetate and sodium sulphate are brought together, lead chromate is precipitated. The various shades of yellow are governed by the relative proportions of the potassium bichromate and the sodium sulphate. Reducing the proportion of the latter moves the colour towards the red while increasing it produces the pale yellows. The precipitated colour can be further treated with caustic soda, which deepens it to scarlet, when it is known as Chinese red. Since its particles are crystalline and break down under friction the colour is unstable.

Although these chrome colours are reasonably fast to light, they should never be mixed with, nor printed over, any colour containing sulphur, as chemical changes occur, resulting in the formation of black lead sulphide. Colours in which sulphur is present include the ultramarines and all the cadmiums.

Similarly, Prussian blue or bronze blue is precipitated from mixing solutions of ferrous sulphate and potassium cyanide. The rich blue-black pigment (ferric ferrocyanide) which results is also known as Brunswick blue. (Both this name and 'Prussian blue' commemorate the place of its discovery.) This blue is a naturally greasy pigment and can usually be relied upon to cause trouble by scumming. Brunswick greens are made by combining both groups of chemicals in various proportions so that the precipitate falls out in different shades of green.

Chrome green, or chromic oxide, is prepared by heating potassium bichromate and boric acid until they are red, and holding this temperature for several hours. This pigment has good permanence. It should not be confused with the Brunswick greens, which are often called 'chrome greens'.

Cadmium sulphide provides a series of colours approximating to the chromes, ranging from a pale yellow to a vermilion. These are also precipitated colours, being formed when sulphuretted hydrogen is passed through a solution of cadmium sulphate. They possess much greater permanence than the chromes and, because of their expense, are not used for commercial printing. Since they contain sulphur, they should not be mixed with, nor printed over, pigments containing lead or copper as the black sulphides of these metals will be formed.

Precipitated colours, being more finely divided than any other pigment, are for this reason well suited for lithography. Their major disadvantage lies in their instability in association with certain other colours.

Titanium white, or titanium oxide, is superseding flake white as the standard opaque white used in lithography. Its manufacture is a complex process in which precipitation, heating and the use of an intermediate base all play a part. It has greater opacity than any other pigment used in lithography and its superiority to flake white is also manifested by its refusal to mottle when being rolled out on the plate.

Flake white has for many years been the standard opaque white for lithography. It is made by reducing the pure metal with fermenting tan bark and vinegar; the carbon dioxide produced by this attacks the lead to form the basic lead carbonate in the form of flakes over the surface of the metal. Because of their oxygen content, both these whites impart excellent drying properties to the vehicle in which they are suspended.

Certain pigments are made by directly heating various chemicals and grinding and purifying the resultant substance. Of these, the most important is the ultramarine group of blues and greens. China clay, sodium sulphate or sodium bicarbonate, coal and sulphur are subjected to prolonged heat. The different shades of the colour are obtained by the use of the sulphate or the carbonate: sodium sulphate produces a lighter and rather more brilliant blue, while sodium bicarbonate moves the blue towards the violet. The different shades of this colour carry the names 'ultramarine', 'oriental blue', 'royal blue' and 'ultramarine green'. They are highly resistant to fading and perfectly stable except in conjunction with colours containing lead or copper.

Genuine vermilion is synthesized by heating mercury and sulphur. The resultant red mercuric sulphide is condensed to form the pigment we know. It is the heaviest pigment used in lithography and also one of the most opaque. It has good resistance to fading and is quite stable except in association with other pigments containing lead or copper. This true vermilion can always be distinguished by its lack of bulk, weight for weight, compared with other inks: a pound of it fits into a smaller tin than those used for other inks.

Certain black and white pigments are made by a fume process, which involves burning suitable materials or chemicals in an oxygen-rich atmosphere and condensing the smoke in special chambers. The coarser particles fall out relatively near to the source of burning, while the finest particles travel the furthest distance. These finer grains are used in the manufacture of the best-quality inks and paints. The two white pigments made in this way, zinc white and antimony white, are not used in lithography, but the black pigments based on carbon fulfil a valuable role. In the case of lamp black, grease or oil is burnt. Ivory black, in spite of its name, is the product of burning bones. Frankfort black, which is now rare as a printing ink, is made by the

combustion of wood. That these pigments are not pure is manifested by their slight removal from a pure black: Frankfort black could almost be described as a deep sepia.

The most widely used of these pigments is lamp black, which is almost exclusively used as the pigmentation in black lithographic printing inks. Even in its pure state, it is slightly contaminated with unburnt minerals. This is said to be an advantage as carbon has no drying power and the presence of these impurities restricts the amount of vehicle which the carbon can absorb, thus keeping it more open to the oxygen in the atmosphere. Because this pigment inclines to the brown it is customary to compound some Prussian blue into the ink during manufacture. This deepens the richness of the black and at the same time gives some drying capability to the medium.

Possibly the most exciting range of colours for lithographers is provided by the lakes. Although these are many and diverse, they possess certain properties in common: these are a brilliance of pigmentation, transparency and little drying power. A lake is different from normal pigments, which are insoluble in water: its colour has no independent existence and it can only achieve its true colour after being made into an aqueous solution which is used to dye an inert powder, usually alumina. After the dye has been struck to this alumina base, it is chemically fixed to make it insoluble in water. This dyed powder can then be suspended in a vehicle to make a paint or a printing ink.

Natural dyes from the madder root which gave colours in the magenta part of the spectrum were replaced at the turn of the century by alizarin, synthesized from coal tar. However, this dye is no longer used in printing inks, having itself been replaced by newer synthetic organic substances comprising a range of compounds based on closed carbon rings or hydrocarbons in association with nitrogen, sulphur, copper, ammonia or phenol.

It will become apparent that the manufacture of these dyes and related pigments is a wide-ranging and complex subject and outside the scope of this work. Lithographers who are concerned about the permanence of their prints, having studied the colour charts of an ink manufacturer, should enquire about the permanence of these materials and their stability in association with the more traditional pigments. It would also be important for them to learn the composition of the inks which they intend to use. Unfortunately, most colours are known by such indefinite terms as 'pillar-box red' or 'leaf green', without any further indication of their chemical structure. It is only occasionally that the name gives some hint of the ink's formulation, as in the case of rhodamine red. While it is possible that the prefix 'rhod-' indicates the presence of the metal rhodium, it is more likely that it is used in the meaning 'red' or 'pink'. The suffix '-amine' is unambiguous and demonstrates the presence of some ammonia derivative. Rhodamine dyes,

which cover the red part of the spectrum, are in fact compounds of ammonia and the carbon ring compound 'fluorescein', itself a fluorescent dye used in making colours possessing this property.

Similarly, 'azo-' compounds always contain nitrogen. These dyes and true pigments cover the spectrum from yellow, through orange, to scarlet, but the majority of them are fugitive. They are compounds of the hydrocarbon benzene and nitrogen. The reds produced in this way are called 'lithol' reds. Toluidine, in the blue part of the spectrum, is one of the more light-fast lakes.

Rhodamine dyes provide reds and magentas and the trichromatic process reds, while the phthalocyanine compounds give trichromatic blues, cyan blue and some greens.

Some lakes can react with other colours, and oxidation can take place between titanium white and iron blue or phthano blue, when either of these colours is used to make opaque tints. Chemical reactions can also take place between any vehicle containing hydroxyl (-OH) groups and pigments containing salts of barium, calcium or sodium, though it is rare with modern methods of making inks.

These lake pigments possess negligible drying power, which must be remedied during manufacture, otherwise the vehicle would have to rely on atmospheric oxygen, thus prolonging the drying period for several weeks.

In some ways it is better to stay with the inks of one manufacturer, so that as experience of using them grows it is possible to learn the performance of the ink thoroughly. For example, some colours shift spectrally when used in tint form and this movement varies according to whether an opaque or transparent tint is made, or, in the case of an opaque tint, whether flake white or titanium white has been used.

Most manufacturers can supply a range of colours far in excess of the number required for printmaking. They can also supply a colour chart of their range showing the characteristics of each colour when used commercially: its light-fastness to bright sunshine, its reaction to alkalis (this is useful to the printer when deciding which colours to use when printing soap packets), and whether the ink can be varnished. With regard to light-fastness, the standards required for commercial printing and those necessary for printmaking show considerable disparity: the fastness of commercial inks is measured in months, whereas the life expectancy of artists' colours should be measured in centuries – though this does not mean that certain pigments used commercially would not conform to this standard.

Some colours conform to British Standards and will have a BS number. This means that any ink with this number on its tin is identical to any other, regardless of which firm made it. These numbers usually apply to some blacks and the trichromatic process inks.

Prints made from the most permanent inks will be satisfactory if kept in a plan press or portfolio, and only displayed for short periods and out of direct sunlight.

REDUCING WHITES

This is a small group of inks which fulfil an important role in lithography, yet by themselves have negligible colour value. They are also known as 'tinting white' or 'tinting medium'. To make an *opaque* tint of a colour, the chosen ink must be mixed to the desired tone with either flake white or titanium white. Reducing whites are used to make *transparent* tints without diminishing the basic viscosity of the ink.

These reducing inks are usually more viscous than pigmented inks, and this is achieved by mixing with the varnish a material which has a refractive index approximating to that of the vehicle, so that when it is in suspension it becomes almost invisible. The most widely used substances in this category are magnesium carbonate and alumina hydrate. Although when in their dry state they are fine white powders, as soon as they have been compounded with linseed oil or linseed oil varnish, this white pigmentation is lost. Both of these substances have an independent use in the studio (see below). It should be emphasized that reducing whites have little drying power, and unless the ink with which they are mixed is a good drier, or driers are added when mixing the tint, they will have to rely on atmospheric oxygen.

DRIERS

There are two forms of drier available to the lithographer, the paste drier and the liquid drier. Liquid driers are based on cobalt, and when added to the ink they have a marked tendency to increase the formation of gloss and cause it to dry with a hard, brittle finish. They are therefore not well suited to the purposes of the printmaker.

Paste driers are based on compounds of manganese and lead, and cause the ink to dry with a semi-matt surface. It produces a more supple ink film than that produced by the cobalt but its great disadvantage is that it will dry very rapidly in the tin, once this has been opened.

These substances do not seem to affect the permanence or quality of the colour in which they have been mixed. It must be realized, however, that the quantities used should be very small, the recommended proportion being half an ounce to eight pounds of ink, or $1:256$. For the average amount of ink used in making an edition this would be little more than a small spot on the end of the palette knife.

MAGNESIUM CARBONATE AND ALUMINA HYDRATE

These fine and very light powders are used in the studio as additives to give body to a slack ink or to reduce the possibility of gloss, to make the ink less greasy and to reduce tackiness. Of the two, light magnesium carbonate is the most widely used.

It is sometimes necessary to reduce viscosity by adding raw linseed oil or thin varnish to the ink, but since these two vehicles are greasy the ink will be more likely to scum. The addition of the magnesium carbonate will counteract this tendency.

It can also be used as a dusting powder, applied after the ink has been printed to reduce gloss. This procedure is not recommended in all cases, as the powder, when used in this way, can alter the tonal and colour relationships in the print. Dusting leaves the ink film with a slight milky coating which is especially noticeable on dark, transparent colours, though light, opaque colours are little affected. Should an intermediate colour which is dark and transparent be too wet for receiving the next colour, the powder can be dusted across it to prevent it from offsetting down to the plate being printed, and also to diminish any gloss that might be present on the print.

Used with discretion, it can be mixed into colours which are opaque or transparent, to give them body and to reduce greasiness in the ink, although there is some risk, if excess quantities are used, that the ink will become too short, that is, rather crumbly in texture, and will be difficult to roll. It will also be discovered that the basic image on the plate will deteriorate and cease to take ink. Magnesium carbonate

Adding light magnesium carbonate to the ink to modify its greasiness and body.

possesses some abrasive properties and is capable of adsorbing grease. Thus it can be seen that this combination of properties is potentially dangerous to the adsorbed image on the plate.

When used for dusting, it is applied with a pad of cotton wool. Pressure should be very light, as there is a tendency for the fibres to stick to the print. Unfortunately, when used to kill the gloss on a finished print, it reduces the bite of the deep, luminous colours. A certain amount of gloss in these transparent colours is permissible in order to enhance the contrast with the more opaque colours in the print, so that a choice will have to be made between undesirable gloss and true colour value.

DRYING RETARDERS

It was noticed earlier that if the first colour in a series dried too quickly, the ensuing colours would be compelled to dry on the surface, forming an unpleasant gloss. This can be avoided by keeping the first colour open with an additive which will retard drying and allow the vehicles from the subsequent colours to penetrate the bottom ink film to be absorbed into the paper.

Additives which retard drying are basically non-drying oils, and are employed in quantities as minute as are the driers. One difficulty which may be encountered is their tendency to reduce the viscosity of the ink as their consistency is very loose. Paraffin can be used, which will also ease the working of the ink as well as encouraging it to form an even matt surface. Vaseline is another well-tried additive, which also has the effect of decreasing viscosity. Finally, there are various patent Gel additives which can safely be used for keeping the ink open.

It can be seen that the three main constituents of the ink – the medium, the pigments and the additives – cannot each be considered in isolation because during the chemical process of drying their functions overlap.

Leaving aside the chemical compatibility and constitution of inks, their behaviour when being rolled out on to the plate must now be considered.

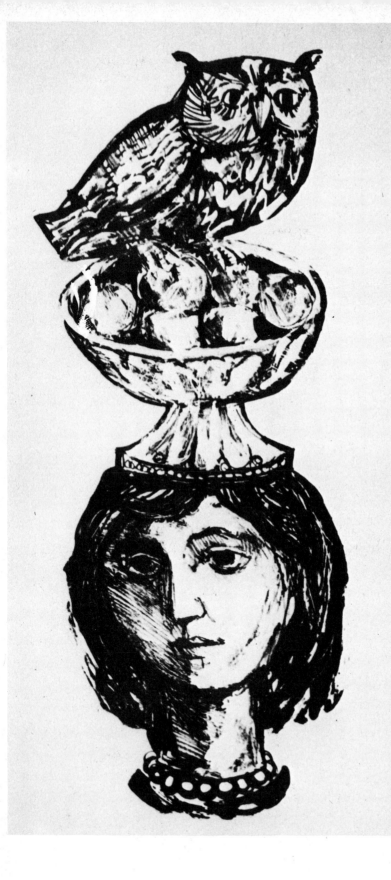

9 Colour proofing and making the edition

Generally, this presents fewer problems than rolling up in press black. If the plate has been properly etched, and as the coloured ink is less viscous than the press black, the image should take the ink quite easily. The method of rolling is the same except that no conscious pressure need be used on the roller. The thinnest possible layer of ink is all that is required to charge the image, and if the tone of the ink is wrong it should be remixed. Using a thicker film will certainly darken the tone of a transparent colour, but it will also introduce the problems of image coarsening, slow drying and gloss.

Certain colours can present difficulties in working, and it is quite common to see a fine film of ink spreading across the non-printing areas. Most, if not all, lakes have this fault. It stems from the ratio of pigments to vehicle, which is lower in lakes because of the inability of the dry colour to absorb as much of the vehicle compared with true pigments. Thus the lakes have less body and their low pigment content makes them more greasy. Furthermore, the dye, being originally water-soluble, tends to bleed into the damping water on the non-printing areas, carrying with it small amounts of the vehicle which gradually become established in the interstices of the image and eventually start taking ink from the roller.

This problem can be minimized by adding some magnesium carbonate to the lake colour to increase its body and to reduce its greasiness. Some addition of reducing white would also improve any slackness of the ink. This form of scumming can also be helped by keeping the damping as meagre as possible. Should the scumming or image coarsening persist, the plate should be put into press black and re-etched. Apart from the lakes, bronze and Prussian blue are prone to this trouble, and damping water which has been contaminated with washout solution, or a damping sponge which has been used for cleaning a plate, can also cause similar trouble.

One other cause of scumming is confined mainly to zinc plates. When an ink of the same tone as the metal, more especially if the colour is a grey, is being rolled out on to the plate, it is difficult to detect whether or not the non-printing areas are taking ink until a proof is taken. If they are, and if this persists without appropriate measures being taken, this form of scumming can become well established.

(Opposite)
Gerald Buchanan, 'Portrait', 1960.

The plate must then be re-etched, and greater vigilance exercised during the rolling process.

Temporary scumming is usually caused by dryness on the non-printing area, and is quickly removed by properly damping the plate and passing the roller quickly and lightly over the appropriate areas.

If it becomes persistent, damping with a weak etching solution followed by gumming should cure it. Inks that are too greasy and consistently cause scumming (if there is no other apparent reason) should have their consistency changed by the addition of small amounts of reducing white or thick litho varnish, together with some magnesium carbonate.

Should the image not be printing well, it must be decided whether this is caused by insufficient inking, faulty adjustment of the press, or by the fact that the image is not accepting ink from the roller. The first two faults are easily cured, but the last can present a more serious problem. It may be caused by inefficient washing out, over-etching, or abrasion of the basic image by the addition of too much magnesium carbonate to the ink that is being used. In each of these cases, it would be best to put the plate into press black and continue investigation from there.

Much time can be wasted by trying to resuscitate an image which is not taking ink, as any remedial treatment is very frequently unsuccessful. After the image has been washed out, and rolled up as far as it will go in press black, it can be dusted with french chalk, properly resensitized and the weaker parts redrawn. In this case, it is inadvisable to give a full etch to these reworked areas. If, when the plate is once more rolled up in colour, it is still rejecting ink, it should be discarded and another plate drawn.

Inks which have been mixed with flake white can also give trouble when rolling up and printing. If there is a fairly large area of unrelieved solid, the roller tends to build up the ink into a mottled texture, and this mottling (known as 'flocculation') is transmitted to the proof. The ink is also prone to building up on the edges of these areas in the form of ridging. The cure is to keep the film of ink as thin as possible and the plate as dry as possible during the rolling procedure. This problem can be avoided by the use of titanium white instead of flake white.

Although litho inks can be broadly divided into transparent and opaque colours, in practice it is found that there is neither a truly transparent nor a truly opaque ink. Relative transparency depends on the relationship between the refractive indices of the pigment and the vehicle. If they were identical, there would be no refraction of light by the pigment floating in the medium, so that the pigment would be as invisible as a sheet of glass lying in a bath of water.

Not more than twenty years ago, it was frequently said that all light-toned colours were opaque and all dark-toned

colours transparent. It was also considered good policy to print opaque colours first. As with all generalizations, there are elements of truth in these. However, since the introduction of the valuable range of yellow lakes, effects unobtainable with the chromes are possible. These lakes, though light in tone, have good staining power and can be used satisfactorily later on in the sequence of printing. When used as one of the final colours, a milky quality becomes apparent when overprinted on a dark colour. This can be avoided by slightly reducing it with reducing white, so that its intensity is not greatly altered. Chrome yellows used in the same position in the sequence give the effect of floating and unrelated areas of colour.

These statements, however, serve to underline one of the beauties of the lithographic process, namely the effects which can be achieved by the juxtaposing and overprinting of transparent and opaque inks.

When a transparent tint is laid over another colour, the tone of one is added to the other. The final colour is darker than either of its constituents, so that the result is mainly, though not always, predictable. Certain exceptions to this rule exist: a transparent yellow over a transparent blue will give a different result from that obtained if the positions of the colours were reversed. In certain circumstances, a magenta overprinted on a viridian will produce a colour that can only be described as an ultramarine. Much depends on the tone and hue of the surrounding colours.

When overlaying an opaque or semi-opaque tint on a darker transparent colour it would be rash to predict the outcome. Tonally it would be darker than the opaque colour but lighter than the transparent one. The colour itself could be a long way removed from either of its constituents. Such overprinting can give unexpected and sometimes disquieting colour relationships.

Inks with good body – that is, inks with a greater proportion of pigment in their make-up – generally work more easily and present fewer problems than the lakes.

From a technical point of view, to make a lithograph which exploits the use of transparent colours is to engage in a difficult process. Most of the inks will incline to produce scum, and unless constant vigilance is exercised during the rolling the ink film will become too thick and produce gloss. As they become thicker, their tone will darken, and in turn this will affect the tonal balance of the final image. From this aspect, there is more leeway when using opaque colours, as thickening the film does not greatly change the tone of the colours. It is only when these problems are understood that the superb presswork involved in prints of Vuillard and others from the Paris School which rely on extensive overprinting can be fully appreciated.

Antoni Clavé, 'La Reine', 1958.

MIXING THE COLOUR

Mixing the ink.

When mixing tints, whether they are opaque or transparent, it is more economical to start with the palest colour in the mixture (usually one of the whites) and to add, very sparingly, touches of the darker colours until the desired colour is obtained. If light colours are mixed into dark ones, the end result will be a pile of ink which will be wasted. An extreme example of this would be to take some black ink about the size of a walnut on to the end of a palette knife and add reducing white to it to make a light transparent tint. It will be found that when half a kilo of the white has been used, the colour is still too dark. When using a colour which is mostly made from white, it is best to start with the white in a quantity which you estimate will print the number of proofs required, and add the other colours to tint it. Since litho inks are strong stainers the addition of these colours will add little to the bulk of the ink. Any additives in the form of driers or retarders can then be mixed into the final colour.

When reducing white is being used to give body to an ink, it is added after the colour has been mixed, as when used in this way it will make no appreciable difference to the colour.

The ink-slab used for mixing and rolling out the colours should be as large as can be accommodated. The ideal is the marble top of an old washstand, which will give plenty of room for mixing the colour at the rear and rolling it out at the front. Failing this, a large litho stone would be suitable, although anything less than a double crown size, (20 in. × 30 in.), will cause difficulty through lack of room. If small stones have to be used it would be more efficient to use two, one for mixing and one for rolling. An alternative method is to have a thick sheet of plate glass set into the bench top. If it rests on a sheet of foam plastic there should be no risk of it fracturing under pressure.

The most useful implement for extracting ink from the tin is a 6-in. palette knife from which half the blade has broken and the raw end ground smooth. Failing this, a 2-in. push knife would be satisfactory. It is always best to use the fewest possible colours in making a mixture, as it will be less frustrating to duplicate it for printing the edition.

Colours as they are mixed should be tested against the original design, if one has been used, according to a special technique. It is tempting to assess the value of a colour from the pile of ink at the back of the slab, or from its appearance when it has been rolled out. This is a misleading way of judging colour as after it has been printed on to the paper and can be seen in its true context it will inevitably be wrong. A pile of transparent colour appears only slightly different in tone and hue from the pure ink.

Since the presence of other colours affects the colour to be matched, this latter colour must be isolated from its surroundings by taking an offcut of the same paper on which the lithograph is to be printed, and cutting into it a window about 1 in. square, or sufficiently small to mask any adjacent colour except the one under consideration when the paper is placed over the design.

Matching is accomplished in this manner: the tip of a clean finger is lightly dabbed against the pile of ink, and this is transferred to the piece of test paper. The ink is extended into a film which approaches as closely as possible the thickness of the printed film of ink. The two colours can then be compared in isolation against the same background.

When matching colour from a gouache drawing some difficulty might arise from the fact that printing inks generally possess more depth and richness, and transparent inks more luminosity than the equivalent colours in the watercolour medium. This disparity can cause the matching inks to be on the anaemic side, as it is tempting to make them too pale in tone.

It is helpful in colour mixing, especially at the proofing stage, to write down the proportions and names of the various colours used in obtaining the required mix as this will save much trouble when duplicating the colour for printing the edition. In fact a working notebook is useful for every phase of the craft. Areas of overprinting from discarded proofs which show unexpected results can be cut out and pasted in, together with written details of the colours and order of printing, for possible future use. This kind of entry can be extended to show the effects of different types of paper on the various inks. Examples of washes can also be saved, with notes on their achievement. All lithographic problems are recurring, and present themselves in unexpected and diverse ways, and as the notebook expands, so does one's knowledge and understanding of the craft.

New methods

There are two approaches to making a colour lithograph. While it is possible to build up an image by extensive use of overprinting to produce different colours – a well-established method which has been used by most of the major artist/lithographers of this century – the principle of building up the design as a form of mosaic has become popular since the war, more especially since the advent of Pop and Hard Edge imagery. This technique brings its own problems, not the least of which is one of unity in the design.

The use of overprinting large areas with transparent colour, and the modification which occurs in the colours by this method, produces unity, but where no overprinting is used in a design the choice of colour becomes a matter of great nicety, and any major deviation from the finally worked out scheme carries the risk of failure. Therefore,

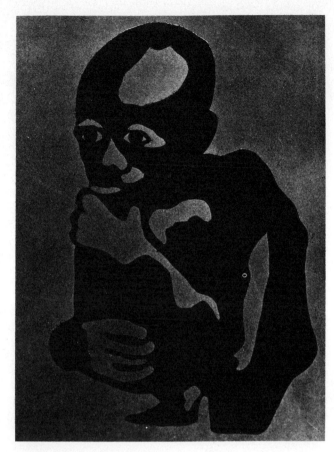

Maria Latham, 'Refugee', 1970.
Single-colour print in black on black
paper. While wet, the ink was
dusted with thermal-setting resin
and gently warmed from the back.
This produces an embossed and
very glossy image.

after the proofing in colour has been completed it is essential
that accurate matching of the colour be achieved when
editioning the print.

The wide range of commercial blacks available to the
lithographer vary from inks drying with a high gloss to
those which will print almost matt. Prints using these
different qualities of inks can provide exciting images, with
very close tonal relationships between the different blacks.
These effects can be extended by printing on black paper,
and dusting the high-gloss ink with thermal-setting emboss-
ing powder or resin. If this technique is being employed,
the gloss ink should be printed last, after the previous inks
have completely dried. While still wet, the gloss ink is
dusted with the powder and the print gently warmed from
the back. This causes the resin or powder to fuse, producing
a hard, glossy image in low relief which contrasts well with
the previously printed matt blacks.

Viscosity of inks

In deciding on the suitable viscosity of an ink, experience
is the only true guide, although certain principles should

be followed. Generally, it is better to use a stiffer and more viscous mixture when printing fine chalking or texture. Inks that are too sloppy, when applied to small areas and image dots, will spread, accompanied by coarsening of the image, filling in, and background scumming. Plates which consist of bold, simple shapes can stand an ink that is less stiff, especially if there are large areas of solid. On this type of image, inks that are more viscous tend to roll up the middle of the areas in a broken manner, leaving scattered spots of paper showing through. A compromise between these two extremes is normally possible and must be made if the plate consists of both types of work.

With bookwork, once the range of colours has been chosen, and as the proofing and editioning is likely to be extended over several weeks, it is possible to mix sufficient ink to meet any contingency and to keep it in an airtight tin. The colour can be covered with a little turpentine to prevent it from drying. If driers are needed in the ink, these can be added as required. If the ink is naturally a quick drier, it can be kept open by the addition of a retarder as well as by covering it with turpentine.

PROOFING IN COLOUR

Although each plate of a multi-plate print is proofed in colour after it has been drawn and etched, it is frequently necessary to reproof the series after all the plates have been printed in sequence. This may be due to major alterations on a plate that is to be printed early, or because it has been decided to change the sequence of printing.

It is not always the case that the first plate to be drawn will be the first to be printed in the edition. When a lithograph is being made without the use of a wasted key, the plate which is likely to contain most of the critical registration is drawn first, and offsets for the subsequent plates prepared from it. It may well be that this plate will be printed last.

Other reasons for reproofing could be discrepancies in registration which have to be corrected, or an unsatisfactory colour scheme that became evident on the initial proofs.

After proofing the plates, there are alternative methods of preparing them for storage. The main criterion should be that the image and the non-printing areas should suffer no deterioration until after the edition has been printed. The colour should be washed out with white spirit and the image coated with washout solution. It is then rolled up in press black and gummed up. When this has properly dried, the plate can be stored. It is sometimes advised that before washing out the colour the plate should be gummed and left to dry, the advantage being that the non-printing areas are protected during the washing-out process. On no account should a plate be stored while the gum is wet as the surface would be oxidized.

Alternatively, when the gum has dried, the press black can be washed out and washout solution applied across the whole plate. This method has the advantage that washing out the press black immediately prior to printing the edition is avoided: the hands need to be scrupulously clean for the printing.

Stones or plates should never be stored when rolled up in colour.

If the work has to be left for an hour during printing, and the ink is a slow drier, the plate can be gummed and left. The gumming will ensure that the ink will not spread during the interval (coloured inks, possessing less viscosity than press black, have a greater tendency to flow). If the ink is likely to dry quickly, it is better to gum the plate and then wash out the colour.

If the plate is left for not longer than ten minutes, it should be covered with a clean sheet of paper to prevent greasy dust from settling on it. The bridge or barrel stave used for drawing (see p. 53) will be found helpful in keeping the paper away from the image. The image should be left *after* a proof has been taken and *before* rolling up for the next proof, so that the ink will not spread.

PRINTING THE EDITION

Having completed the proofing, with any necessary changes in colour or drawing having led to a final acceptable image, the print is now ready for editioning. Preparations for this must be carried out with the greatest cleanliness and care. It should be borne in mind that the result of perhaps many weeks' effort is being offered for sale, and in the same way that a customer would refuse to buy a dirty or torn packet of tea, he should not be expected to buy a print in the same condition. These prints will deserve the best in terms of care and materials which the artist can give to them.

Printing an edition can be a long and monotonous process, mainly because the excitement of building up the image for the first time is absent. It is no easy matter to print fifty or more lithographs, controlling the damping and inking, each one of them having to go through the press as many times as there are plates, and each one as nearly identical as the artist can achieve. At the same time, the margins and backs must be as immaculate at the end as they were before printing commenced. It is a process which demands patience and attention to detail.

If a transfer press is being used, it should be checked for the presence of any lubricating grease which may have strayed from the runners or the scraper. If plates are being printed the platform must be cleaned with petrol and any grit removed from its surface. The pressure must also be adjusted. Since these tasks are dirty, they should be carried out first, before proceeding to the cleaner ones.

If the backing papers are dirty, either the bottom one should be replaced, or a sheet of clean cartridge should be interposed between them and the paper which is being printed.

A clean sheet of newsprint should be used to cover the top of a small, conveniently placed table to receive the pile of paper on which the lithograph is being printed, the top six or so sheets being cheaper paper which can be used in the initial stages before the plate is printing properly. If desired, some proofs can be taken on paper of a different quality from that used for the main edition. This can be a cheaper grade, but otherwise the quality of the prints should be the same as the main edition. Finally, at the bottom of the pile would be the best paper.

If the plate is smaller than the platform, and the paper larger than the plate, there is a danger that the paper margins will become soiled. Therefore, after rolling up the plate, the platform must be cleaned with petrol before laying down the paper. Several rags should be set aside for this purpose so that a clean one is always available for the last wipe over the surface.

An alternative method involves the use of a piece of paper the same size as the platform into which a window has been cut of the plate size. This is placed into position just before the paper is laid on the plate. The method is particularly helpful if the roller, because of its size, deposits ink on the platform.

It is advisable to use a scraper which is only slightly longer than the width of the image, or in any case, shorter than the width of the plate. This will prevent the formation of indented plate marks on the paper. To avoid similar marks at each end of the image, the extremities of the plate should be indicated with chalk lines on the side of the platform, so that there is a clear indication of how far the bed can be pushed before engaging the pressure. Similarly, the distance through which it can be safely wound can be gauged, so that the whole of the image and the registration marks are printed without the scraper going over the front or back edges of the plate.

The ink is then mixed, and the plate is washed out and fixed to the platform. When a pale tint is to be printed it is sometimes advised that the image should only be washed out with white spirit, without afterwards applying washout solution, as the washout is sufficiently strong to stain the pale printing ink with brown. This is certainly true, but the effect should clear after a few proofs of spare inking. It should be remembered that the image on a plate is very vulnerable, and any process which can weaken it should be used with care. Horsell's recently introduced C1175 white emulsion washout solution should solve this problem.

During the process of printing, the sheets should be handled carefully to avoid soiling them. It is useful to have a shallow box near by, containing french chalk into which

the fingers can be dipped to absorb any grease or perspiration and reduce the necessity of continually washing the hands.

With regard to this problem, lithography is a punishing craft because of the continual alternation of greasy and wet hands. Many remedies have been tried but none is really successful. Rubber gloves should be rejected as their use destroys the direct and intuitive contact which the medium can give. Possibly the best solution is to endure the discomfort of cracked or chapped hands and to employ one of the many available emollients at the end of each printing or proving session.

As the prints are taken, they should be carefully inspected for unequal rolling, poor inking, scumming or filling in and extraneous dirt, before being hung in the drying rack to await the next colour.

When planning the printing of an edition, much depends on the drying qualities of the inks being used. If possible, at least one or two colours should be printed in the day. If the edition is a large one, or if some unforeseen difficulty arises, it would be unlikely that more than one colour would be achieved.

Normally, the first colour would be the quickest colour to print, as problems of gloss are unlikely to be encountered and the paper can be placed on the plate a little more freely than when laying to registration marks. In this context, working with the offset press is much quicker because of its simpler method of registration.

When cutting registration marks it is a matter of choice whether to do this immediately after taking each proof, or to wait until they can all be cut at the same time. The latter course is recommended, as once the rhythm of printing has been established it is unwise to interfere with it.

If the time between printing each colour is too short, the ink already on the paper will be too wet to take the ink from the plate, and will instead offset on to the plate, possibly causing scumming and image coarsening. If this occurs, printing must be suspended until the paper is ready, and the ink which has offset on to the plate must be promptly cleared before it becomes established.

If the colour which has already been printed is opaque or pale, dusting the proofs with magnesia powder will usually make them dry enough for printing to continue. In the case of dark transparent colours, it is advisable to make a test with one of the first proofs to see how much the magnesia will alter the colour, and it may be better to wait for another twelve hours if the colour is very wet. With this type of colour, anticipating the problem by adding a little matt drier to the mixture is better than any cure. Very pale tints which contain a high proportion of reducing white should have the drier added to them as this white is a very slow drier. The amount of oxygen in any pigment which a pale transparent tint would contain can be discounted as a drying aid.

Ball-pattern drying racks.

As the print progresses, the chances of gloss forming are increased, and measures to combat this become more urgent. It must be emphasized once more that the best solution to this problem is to use the thinnest possible film of ink. It will dry more quickly, and because there is less oil on the paper, the tendency to gloss will diminish.

Patent drying racks can be bought, and are very efficient. They generally consist of a series of large glass, porcelain or rubber marbles resting in slots, at about 6-in. intervals along the length of a 6-ft piece of timber of 4 in. × 1 in. section. Two prints can be carried in each slot, back to back.

An alternative, but equally efficient, print drying rack can be made in the studio with plastic clothes pegs, screw eyelets and some thick nylon string, fixed to a 6-ft length of 2 in. × 1 in. timber. Half-inch screw eyelets are fixed at 1-ft intervals along the narrow side of the timber. A sufficiently long piece of nylon string is well secured to one of the end eyelets. Plastic pegs are threaded on to the string through the holes at their tops, so that there is about 6 in. between them. The string is threaded through the eyelets after each alternate peg. For extra security, the number of eyelets can be increased to one per peg, so that they will be unable to slip. When all the pegs have been threaded, the string is tightly secured to the eyelet at the other end.

Several of these racks can be mounted parallel to one another, by attaching them to suitable end frames. By the use of pulleys and rope, these units can be suspended from the ceiling and lowered during printing. Afterwards they can be raised out of the way to prevent the proofs being soiled by the human traffic in the studio.

When the edition is complete and sufficiently dry to handle, the prints should be signed, numbered and dated. It is

Top: Section of ball-pattern drying rack, to show the operating principles. *Above:* Drying rack made from spring pegs, vinyl-coated cord, screw eyelets and 2 in. × 1 in. timber.

advisable for the first few weeks to store them interleaved with a fairly rough paper, which will hold the prints apart and prevent offsetting or staining on the backs. MG paper is suitable for this purpose as long as the rough side is facing the image. Alternatively, a white tissue like onion skin, which has a built-in cockle, would be very suitable. This interleaving is more necessary when sized, hot-pressed or other papers less absorbent than waterleafs or antiques have been used, and if the image comprises large areas of over-printing with transparent colours.

When it is certain that the edition has been satisfactorily completed, the images can be washed out from the various stones or plates; there is no need to gum them, but they must be allowed to dry before storing them.

The tradition of ensuring that the print cannot be duplicated at some future time is a long one, and is achieved in the various printmaking media by taking an impression of a cancelled block or plate. In the case of relief prints or etchings the cancellation takes the form of an incised cross over the image.

In lithography the image can similarly be cancelled by the action of carbolic acid on stone or caustic on the plate. After this, the plate is gummed up to desensitize the newly exposed area. When this is dry, the plate can be washed out and rolled up so that a cancellation proof can be taken.

CLEANING UP

It cannot be emphasized too strongly that this chore must be completed at the end of each working session, and quite frequently, at intervals during the session.

If corrosive solutions or solvents are being used, they should be returned to the cupboard immediately to avoid the possibility of their being accidentally spilt over the work. Rollers and ink slabs should always be cleaned as soon as possible to prevent the ink from drying on them.

The spare ink on the slab should be scraped up with a 2-in. or 3-in. push knife, and collected into a sheet of waste paper.

The palette knives should also be scraped with the push knife to remove the bulk of the ink. Together with the roller, they are then laid on the slab and sprinkled with paraffin. The roller should be spun a few times so that all the ink on its surface is dissolved in the paraffin. It is then wiped with rag and placed in the rack.

The palette knives are similarly cleaned and stored. The inky paraffin is cleaned from the slab with rag, and this is followed by wiping it over with some clean rag damped with petrol.

If possible, cotton rags should be used as they are very absorbent. However, it is possible to use one of the various forms of absorbent paper wipers that are now being made.

Flag fan. This can be made from a 1-ft. length of 1-in. dowelling, rebated for about half its length. The flag is made from thin card folded in half and stapled in position. Alternatively, a more durable flag can be made from a zinc plate or a board, with a sleeve of heavy polythene which is sewn or stapled on to the flag.

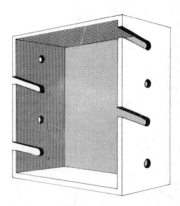

Roller rack. This can be about 2 ft. high, allowing 1 in. between the stored rollers. The width depends on the length of the rollers. The rack should be fixed to a wall, and the front protected by a sheet of polythene, or a door hinged at the top or the bottom.

Palette knife rack. This is made from two pieces of 1 in. × 1 in. wood, into which rebates are cut of the required lengths. These pieces of wood are then glued together as shown, and faced with a strip of three-ply. Holes are drilled to take two long screws for fixing to the wall or a cupboard.

Susan Samuels, 'Cat', 1973.

10 Papers and paper-making

The general properties that all printing papers should possess, namely the ability to take an accurate impression by whichever method is used, dimensional stability and good opacity, apply particularly to lithography, though other properties are also desirable. A good acid/alkali balance should be present, so a controlled pH value is necessary. This is important, especially in direct printing, where there is the possibility of either acid or alkali from the paper affecting the working of the plate. Neutral pH also inhibits the discoloration of paper due to ageing.

In terms of the actual mechanics of printing, lithography is quite versatile and can give an image on fairly diverse papers and other surfaces, especially if offset printing is used. It can be printed on to highly textured cloth; with transfers it is used in the ceramic industry, and in its offset form it has been for many years the main method used in tin printing. However, certain reservations must be made.

It is not always possible to reconcile properties which may help with the actual mechanics of printing and press-work with properties which should enhance the qualities of the image. It is easier to transfer a film of ink on to a paper which has a smooth and possibly a glazed surface than it is to a paper with even the slightest texture. If both the printing surface of the plate or stone and the surface of the paper are rough, it follows that the transfer of ink must be incomplete unless the right countermeasures are taken.

There is a general rule which broadly applies to all forms of printing: good printing is possible only if the printing surface and the receiving surface are sympathetically contrasted. Generally, a hard surface will print well on to a resilient one, and vice versa. Printing a grained stone on to a rough paper is a misuse of materials and there is little point in trying to print on to metal with a metal plate. In printing, there must always be a measure of resilience against firmness.

Various measures can be taken to establish this relationship between the printing and receiving areas. Damping the paper to soften it before printing has been practised for centuries in both relief and intaglio methods and is frequently also practised in lithography. This has the effect of flattening the tooth, or texture of the paper while the impression is being taken, so that the image in fact appears on a smooth surface surrounded by a margin of uncompressed paper.

In colour lithography, which involves continuous problems of registration, it is important that the paper be dimensionally stable, as all paper, because of its vegetable origin, is hygroscopic and expands when moisture is absorbed. As will be shown later, this can ruin the most careful preparations which might have been made to ensure good registration.

Another factor governing the choice of paper is the economic one. Cost would obviously affect the decision to use hand- or mould-made paper, or good-quality machine-made paper. In view of the diminishing quantity of hand-made paper that is coming on to the market, availability must also be considered. It is not too fanciful to foresee a period in the fairly near future when such a fine material will have become a curiosity, in the same way as the hand-made furniture and other artifacts which our forefathers enjoyed. Several factors are involved in the decline of the craft. The number of apprentices is diminishing and as the journeymen retire, production contracts. Another factor is the uncertainty in the supply of cotton rags. Present-day cotton fabrics, even if not extended with synthetic fibres, frequently contain additives to make them crease-resistant or drip-dry, which also render them unsuitable for papermaking. The makers now prefer to use raw cotton.

The most important constituent of all paper is cellulose, derived from vegetable sources such as cotton, esparto grass, straw and wood. Cotton is used for hand- or mould-made papers and is sometimes incorporated into the better-quality machine-made papers. The unique and seductive quality of Japanese papers stems from the use of fibres from the mulberry and other trees indigenous to that country. The over-all quality of the final product is closely dependent on the quality of the raw materials. The best-grade machine papers are made from esparto grass, possibly with the addition of cotton. Cheaper papers rely on a mixture of esparto grass and wood, while straw is used in the making of boards.

This vegetable matter has to be bleached and reduced by mechanical or chemical means to very small fibres which can then mat together to form the paper. Wood is broken down by grinding the trunks, or it can be reduced to chips and cooked with alkali or acid. Both processes provide the fibres, one being known as 'chemical wood' and the other as 'mechanical wood'. Cotton, esparto grass and straw are also prepared by the chemical method. The resultant fibres in this state are too coarse, and have to be subjected to a beating process, which cuts them into very small lengths and frays them so that they can interlock more easily. This process can be controlled to produce fibres of varying lengths. Long fibres make a very strong paper, e.g. Kraft paper, while short fibres produce a more sympathetic surface for taking a printed image, but are consequently much

weaker. As with most things, compromise solutions have to be adopted.

The different finishes of machine-made papers is caused not so much by the variation in the basic raw materials as by the additives and by the treatment which the web or sheet is given during or after its manufacture. Additives can be introduced at several stages during the manufacture, and their function is very important. They can take the form of chemicals or inert substances which colour, waterproof, improve opacity, apply the surface or make the paper tear-resistant. The surface can also be treated to make it smooth or glazed. The substances used include clay, size, chalk, resins, plastics and pigments.

MACHINE-MADE PAPERS

The first paper-making machine was developed by the Fourdrinier brothers from a prototype patented in France by Nicholas Robert in 1798. It began operating in 1803, and from it were developed today's machines capable of producing a web of paper thirty feet wide.

The fibres and any additives required are mixed with water and fed to the 'wet' end of the machine. This machine is divided into several well-defined sections, the first of which is a moving endless belt of fine wire mesh. By the time the mixture has travelled the length of this, it has lost about 40 per cent of its moisture. It is then 'couched' on a moving felt bed, which extracts more water. This bed moves it on for the next treatment, and by this time the paper has sufficient strength to exist without support, so that it can progress through the various banks of rollers which comprise the remainder of the machine. The web is collected on a reel at the 'dry' end.

The rollers fulfil such purposes as drying, pressing and glazing. The use of these, and the size tubs, depends on the quality and type of paper required. Sizing can be carried out on the web, to make the paper known as 'engine-sized', or in the case of good-quality papers it is done at the end as a separate process, using gelatine. Paper treated in this way is known as 'animal tub sized'. Unsized papers tend to be rather pulpy and fluffy; well-known types are blotting, newsprint and antique papers for bookwork.

After the web has been made it can be treated in the super calender, a machine consisting of vertical banks of rollers, some highly polished and some lined with fine cotton. This gives the paper a very smooth surface. Art papers and cast-coated papers go through a process of being coated with china clay, white pigment and other materials before being calendered. Paper designed for lithography is usually slightly waterproofed by the addition of resins to help it withstand the damping process, thus preserving its dimensional stability.

One of the main differences between machine- and hand-made paper lies in the meshing of the fibres. Hand-made paper has no directional grain, but because of the tension applied over the very long machine used in papermaking, the fibres tend to be pointing in the same direction, that is, down the length of the web. When damped, hand-made paper stretches evenly in all directions, but the machine product, like wood, expands more across the grain than it does down its length.

For several reasons it is important for the printer to know the direction of the grain in the paper he is using. For example, in bookwork the grain should always run parallel to the spine; otherwise, during the gluing-up process, or if the book becomes damp through being stored in humid conditions, the pages will expand, not outwards when little permanent damage will be done, but up and down. Since the sewing and glue will hold the spine in place, characteristic fan-shaped cockles will form, and become a permanent feature of the book.

Therefore, all paper manufacturers indicate the direction of the grain on the wrapping paper of each ream so that the printer can adjust his work accordingly. If a batch of paper has no indication of grain, it can be discovered by simple tests. Machine-made paper is more springy down the length of its grain and more sloppy across it. If a square is cut from a sheet of unknown origin and is held by two adjacent corners, it will bend under its own weight. If the test is repeated at right-angles, holding the next edge, the difference between the amounts by which the paper bends will be apparent.

Alternatively, if the paper is held between the thumb and forefinger on its top edge, a strip can be torn from it using the thumb and forefinger of the other hand. If this is repeated at right-angles, it will be found that the tear along the grain is much cleaner than that across it.

Paper, because of its hygroscopic nature, reacts sensitively to relative humidity, and before a parcel from the makers is used it should be left to adjust to the average conditions in the studio. Most printers exercise close control over the humidity in the machine room, as even the slightest movement in the dimensions of the paper can radically affect the registration of halftone blocks or plates, which is measured in thousandths of an inch. Although such accuracy is not normally required for printmaking, it is as well to understand why the proof can fit the registration marks on the plate one day, while in spite of the most careful working, they will not coincide on the next. This may be due to a sudden change in humidity overnight (which is very common), or it may be that the grain is going across the print instead of along it. The larger the print, the greater will be the discrepancy.

Paper manufacturers do their best to keep this sort of movement to a minimum by 'mill conditioning' the paper.

When the paper comes off the machine, it still contains about 4 per cent of water. It has been discovered that when paper is exposed to conditions of high relative humidity for the first time, its movement is greater than on any subsequent exposure. This expansion is of the order of 4 in. in every 100 in. across the grain and $\frac{1}{2}$ in. in every 100 in. along the grain. Mill conditioning therefore utilizes this, and the paper is deliberately exposed to high relative humidity to minimize any later expansion.

When unpacking paper in the studio, if the conditions are very humid too sudden a transition from the waterproof packing to the studio bench can cause the paper to cockle as it takes up moisture to balance with the atmosphere. This should therefore be done gradually, by folding back the wrapping from the middle of the packet increasingly over several days until the paper is fully exposed, leaving the edges until the last. Some authorities recommend keeping the waterproof wrapping intact except for a slit through which each sheet can be abstracted as it is required.

PAPER QUALITY

In printmaking, it is essential that the paper makes a positive contribution to the final image. It should not be regarded as a passive vehicle used for supporting the ink. If there is any possibility of choice, the selected paper should match the quality and content of the image. Some prints demand a brilliant white paper, while for others a more muted white would be appropriate. The surface texture of the paper should also be considered. The softer quality of an unsized paper will suit the more atmospheric and chalky type of work, but work with more linear or hard-edged characteristics will gain from being printed on paper which itself possesses these qualities.

Antique papers can be divided into two groups, wove and laid. Laid papers have the very characteristic rectilinear wire mark in their substance, which is absent in antique wove papers. Both papers will take good impressions from the plate, especially if offset is used. In heavier weights, wove papers possess a reassuring bulk, but lack the crackle of calendered papers. Being only lightly sized or completely unsized, they are quite absorbent, and it is unusual to encounter any problems with gloss when using them. Laid papers may present some difficulty when printed direct: the watermarks in them indicate thinner substance where they occur, and the all-over nature of the wire grid can be obtrusive unless the paper is damped before printing, or very heavy pressure is used.

Cartridge papers have some similarity with wove papers, except that they have been sized to withstand drawing. They are therefore somewhat less absorbent, so that problems with gloss might occur. However, their slightly rough

surface makes them very suitable for the litho image. Closely allied to antique wove and cartridge papers are cover papers, which some manufacturers pair with the others in terms of colour range. These have the advantage of heavier weight than is usually available in the normal run of printing papers. Certain of them (e.g. Royal Cornwall) have been successfully used in printmaking for many years.

Cartridge papers can be calendered to produce a very smooth surface. This process also has the effect of compacting the surface fibres, which further reduces its powers of absorbing the vehicle. However, the extra smoothness allows the paper to take impressions accurately from thinly rolled up images, and this is essential on this type of paper to avoid the gloss which accompanies extensive overprinting with films of ink that are too thick.

Sometimes these calendered papers are sold as 'process cartridges' or 'parchments'.

There are some types of white card on the market which are suitable for printmaking, and of these the card known as 'twin wire' is probably the best. It is formed on the papermaking machine by using two webs, which are stuck together with the wire sides facing and the smooth sides forming the two surfaces of the card. They can be obtained in glazed or matt qualities.

Most papers and boards produced today, when compared with similar products made twenty years ago, are of a much more brilliant white, even allowing for fading in the older paper. This surface can present a challenge to the artist, who will probably discover that the colours must be kept in a higher and more aggressive key as muted colours are dominated by this type of background.

Coated papers should be avoided for serious printmaking, because the surface, being designed for fine halftone work, is almost too perfect and lacks the sort of character which can act as a good foil for a lithograph. However, art papers and cast coated papers sometimes can be used effectively for personal ephemera such as greetings cards, so a word about printing them might be appropriate. Cast coated papers, especially, are very absorbent and unless proper precautions are taken, all the vehicle from the ink will penetrate into the surface, leaving the pigment as a free powder, which of course quickly brushes off. If this happens, the prints will have to go through the press once more, while the plate is inked with fixing varnish. Using very careful registration, this is overprinted on to the powdery image on the cards. Being a very quick drier, it should be applied as a thin film to avoid unwanted gloss. Any subsequent plates can then be printed.

This problem can be avoided by adding driers to the ink so that it will dry before any measurable absorption has taken place. The inks, when they have been mixed, should be tested as a smear on a piece of the cast-coated paper to be used, in the same way as when mixing and matching

colour, except that in this case it is the drying time that is being judged. This should be not longer than three hours.

Cheaper papers are more suitable for proofing in colour, though unsized papers which tend to pluck when being impressed should be avoided. MG paper is excellent for this purpose, having a good white surface for printing, while its reverse is ideal for making offsets. It is usually sold in only the one weight, about 80 gsm. MF papers are also useful for the preliminary stages.

More economical is the paper known as 'newsprint'. This is an unsized wood paper which discolours very quickly, but is suitable for proving the plates or stones before etching them. Care should be taken when releasing this paper from the plate after printing, as it has a marked inclination to tear. The fibres of newsprint, being less strongly compacted than more expensive papers, stick to the press black. When lifting the paper from the plate, it should be done very slowly from one end. When an inch or two has been released, the paper should be pulled back on itself and peeling continued with the free end in this position until it has separated from the plate. It will be found that very little paper has stuck to the image.

Animal tub sized papers such as writings will take a lithographic image very well, and for fairly small black and white prints they would be most suitable. Their main disadvantage is their lack of weight and bulk, but this can be offset by using the traditional method of pasting them to a thick mount of contrasting substance.

There are certain types of machine-made papers which do not fall into any of the above categories, and are designed for certain specialized uses. Among these would be the range of papers used for casing and binding books. Some of them are positively textured, but not more than can be handled by the offset press.

HAND- AND MOULD-MADE PAPERS

The raw material for these papers is of the highest quality, including cotton and linen. The preparation of the ingredients is similar, but on a more modest scale, to that used in making machine papers. The cotton and linen fibres are naturally long and easily fibrillated at the ends, which ensures good interlocking. Thus the paper which they make is exceptionally strong and durable.

After beating, the pulp for the paper, together with the additives, is introduced into a vat where it is thoroughly mixed. The sheets of paper are formed when a mould comprising a base of fine wire mesh surrounded by a detachable wooden frame is dipped into the mixture and withdrawn with a characteristic double shake, once sideways and once lengthways. These movements cause the fibres to interlock in a random and non-directional manner. Much

of the excess water drains through the mesh, after which the wooden frame is removed and the matted fibres turned out and couched on a felt sheet. Another sheet of felt is laid over this ready to receive the next sheet of paper. When the pile is sufficiently large, it is pressed to squeeze out the water and the sheets of paper are removed to the drying loft.

Mould-made paper differs in that it is made in the form of a web over a wire-covered cylinder, and can be distinguished by having either one or two deckled edges as opposed to the four on true hand-made paper. Otherwise there is little to choose between similar papers made by either method.

After drying, the paper may be treated with animal size. Lightly sized paper is known as 'soft-sized', while heavily treated paper is called 'hard-sized'. Paper which is unsized is known as 'waterleaf'.

After this, the paper may be subjected to pressing with heated rollers, when it becomes 'hot-pressed'. This compacts the fibres near the surface and produces the typically hard quality associated with this type. Cold-pressing makes a similar but less pronounced surface. These hand-made papers can also be known as 'wove' or 'laid', according to the pattern of wire mesh used in the mould.

Of these hand-made papers, the most suitable for lithographic purposes are the waterleaf and soft-sized varieties. They possess a greater capacity for absorbing the vehicle in the ink than the hot-pressed or hard-sized papers, which encourage the formation of gloss. However, these latter papers can be used quite satisfactorily after being damped, though to avoid registration problems it would be better to reserve them for single-colour printing.

The rougher and heavier weights of hand-made paper are not really suitable for lithography. The heavy paper lacks resilience, while the rough surface would be completely flattened by the extreme pressure needed for printing it.

Most manufacturers of hand-made and mould-made papers sell imperfect products more cheaply, which are generally quite satisfactory in use: they are usually known as 'retree' or 'outsides'.

PAPER SIZES

Most papers can be obtained in several weights and sizes, and in Britain, over many centuries, the various sizes have developed interesting but confusing names. The situation is also aggravated by the existence of three standards, each with its own nomenclature, one for hand-made papers, one for writings and one for printings. Since the weight of each type was described in pounds per ream, and as there were nearly a dozen different shapes, and many of these were available in different thicknesses, the proliferation of figures confused the situation even further.

The conversion to metrication in the British printing industry is governed by recommendations BS 3176 of 1959

and BS 4000 of 1968, based on the acceptance of the ISO paper sizes, which have been in use for many years in Europe.

The A sizes are used for printing papers and the B sizes for writings (handmade paper is not covered by these recommendations). The largest A sheet is A0, measuring 1189 mm × 841 mm (1 square metre in area). These dimensions are calculated so that the ratio of the longer side to the shorter one is $\sqrt{2}:1$, or $1.414:1$, and any straightforward halving of the longest side will always produce a sheet of the same proportion, $1.414:1$. A method of describing the substance of a paper in terms of grammes per square metre (gsm) was also included in BS 4000.

Since it is still possible to buy paper using the old system, their names and dimensions (in inches) are listed below:

Crown 15 × 20
Demy 17½ × 22½
Medium 18 × 23
Royal 20 × 25 (used mainly for card and board)
Imperial 22 × 32 (used mainly for drawing papers)
Double Crown 20 × 30
Double Demy 22½ × 35
Double Medium 23 × 36
Double Royal 25 × 40
Elephant 27 × 40 (a hand-made paper size)
Quad Crown 30 × 40
Antiquarian 31 × 53 (a hand-made paper size)

It will be seen that the larger sizes are multiples of the smaller, and are obtained by doubling the shorter dimension. Dividing the longer dimension will produce book sizes such as (from Crown, 15 × 20):

Crown Folio 15 × 10
Crown Quarto 7½ × 10
Crown Octavo 7½ × 5

This method of sizing has the advantage for the designer that when folded down to octavo sizes, the differently proportioned papers will give different page shapes to work on. As the paper is reduced by folding its larger dimension, the proportion of the resultant pages alternates. This is most pronounced when using Royal sizes, which alternate from nearly a square to a rectangle nearly twice as long as it is broad. Using international paper sizes does not mean that all books will be made to the same proportion, as there are many ways of folding a sheet of paper.

Since some of the writing sizes have finishes which are not obtainable in the printing range, these are given below:

Foolscap 13¼ × 16½ (double foolscap 16½ × 26½)
Pinched Post 14½ × 18¼
Post 15½ × 19
Large Post 16½ × 21

William Gropper, 'Witch'. Black and white lithograph, 16 in. × 12 in.

Further reading

CRAFT METHODS

ANTREASIAN, Garo, and Clinton Adams: *The Tamarind Book of Lithography*. New York, 1970. An exhaustive analysis of the printmaking techniques employed at the Tamarind Workshop. It contains valuable information about the many research programmes undertaken by the workshop.

BROWN, Bolton: *Lithography for Artists*. Chicago, 1929.

CUMMING, David: *Handbook of Lithography*. London, 1904; new edition 1949. The new edition was much expanded, with chapters on platework, rotary printing and photo-litho. Although a printers' manual, it contains much of value to the artist.

GRIFFITS, Thomas: *The Technique of Colour Printing by Lithography*. London, 1940; repr. 1944. A valuable book written by a master lithographer who was for many years in charge of the craft at the Baynard Press.

HARTRICK, A. S.: *Lithography as a Fine Art*. Oxford, 1932. This book is interesting because of the author's involvement with the craft during the early years of this century. He was a founder-member of the Senefelder Club, and taught at the Central School in London.

HULLMANDEL, C.: *The Art of Drawing on Stone*. London, 1824.

JONES, Stanley: *Lithography for Artists*. Oxford, 1967. With a historical survey by Quentin Bell. Stanley Jones is Director of the Curwen Studio, and therefore writes with great experience and authority. This is an instant reference book to be carried in the overall pocket and consulted when faced with one of the many problems which all too frequently occur.

KNIGEN, Michael, and Murray Zimiles: *The Technique of Fine Art Lithography*. New York, 1970. A workmanlike book addressed to the first- or second-year student.

PENNELL, Joseph and E. R.: *Lithography and Lithographers*. London, 1915. Valuable for its detailed history of the craft, but its treatment of colour printing is surprising in view of the spate of colour prints which had been made in France during the previous 30 years.

RANCOURT, A.: *A Manual of Lithography*. London, 1832.

RICHMOND, W. D.: *The Grammar of Lithography*. London, 1878 (12th ed. 1912).

SENEFELDER, A.: *A Complete Course of Lithography*. London, 1819.

WEAVER, Peter: *The Technique of Lithography*. London, 1964.
WOODS, Gerald: *The Craft of Etching and Lithography*. London, 1965. *Introducing Lithography*. London, 1969.

HISTORY

BERSIER, J.: *La Lithographie originale en France*. Paris, 1943.
GILMOUR, Pat: *Modern Prints*. New York, 1970.
LINDEMANN, Gottfried: *Prints and Drawings*. London, 1970.
MAN, Felix: *150 Years of Artists' Lithographs*. London, 1953.

ARTISTS

ADHÉMAR, Jean: *Toulouse-Lautrec: oeuvre lithographique*. Paris, 1965.
ESCHER, M. C.: *The Graphic Work of M. C. Escher*. London, 1961.
LAVER, James: *Sixteen Lithographs by Contemporary Artists*. London, 1948.
MOURLOT, F.: *Picasso Lithographs*. Monte Carlo, 1949–56.
NAGEL, Otto: *Käthe Kollwitz*. Dresden, 1971.
ROGER-MARX, Claude: *The Lithographs of Toulouse-Lautrec*. Monte Carlo, 1948.
— *The Lithographs of Bonnard*. Monte Carlo, 1952.
— *The Lithographs of Renoir*. Monte Carlo, 1951.
— *L'Oeuvre gravé de Vuillard*. Monte Carlo, 1948.
SANESI, Roberto: *The Graphic Work of Ceri Richards*. Milan, 1973.
WARTMANN, Wilhelm: *Honoré Daumier. 240 Lithographs*. London, 1946.

Glossary

A physico-chemical phenomenon manifested as a very close union between certain substances which does not cause changes in their chemical structure. Carbon can adsorb toxic gases, hence its use in gasmasks. Certain fats can adsorb limestone, thus forming the basis of the lithographic process. ADSORPTION

Machine-made paper that is unsized or lightly sized. Used mainly for books, or for material with a period flavour. Can be wove or laid. Some are suitable for printmaking. ANTIQUE

A type of paper on which one or both sides have been coated with china clay. Used for fine-screen halftone blocks. ART

Animal tub sized. The use of gelatine to coat better qualities of machine paper after it has been made. ATS

Lithography as practised by artist-printmakers, the plates drawn, proved and printed by the artist. AUTOLITHOGRAPHY

From 'azote', without life. Applied to certain nitrogen compounds in association with carbon groups, forming azo dyes, and used in making lake colours. AZO

The surface in a printing machine, on which the block, type or plate is fixed, ready for inking and impressing. BED

An inert white powder sometimes added to expensive or powerfully staining pigments, as an extender; also used as a base for lake colours. BLANCFIXE

A thick sheet made from rubber and fabric, used as the dressing on the impression cylinder of offset presses. BLANKET

The quality of ink which is governed by the relative proportions of solids (pigments) and liquid or semi-liquid (the vehicle or medium). BODY

Dusting a metallic powder on to the wet ink or varnish on a print to make a gold- or silver-coloured image. Since the development of metallic inks possessing acceptable working characteristics, the process is being superseded. BRONZING

A set of large rollers used in paper-making to impart a smooth or glazed surface to coated and uncoated papers, such as Process Cartridge (uncoated), and Art Paper (coated). CALENDER

A type of antique paper which has been well sized. CARTRIDGE PAPER

CAST–COATED PAPER	A coated, calendered paper with a mirror-like surface.
CHEMICAL PRINTING	Senefelder's original term for his new method.
CHROMOLITHOGRAPHY	A term used by Engelmann to describe his patent of 1838, involving the overprinting of colours to form polychromatic images. Some authorities credit Senefelder with the invention.
COUNTER-ETCHING	The preparation of plates or stones to make them more sensitive to grease, or the resensitizing of non-printing areas in order to add to the image.
DEEP ETCH	A method of securing an image on a machine litho plate by etching it slightly in intaglio. It is frequently employed when the edition is to be very large.
DELIQUESCENCE	A property of certain salts: absorbing water and liquefying when exposed to the atmosphere.
DESENSITIZING	Processing the non-printing area of a plate or stone so that it will accept no more greasy drawing.
DIN SIZES	The basic metric sizes of paper now in use in Britain and Europe. Stands for Deutsche Industrie Norm, the German national standards institution.
ENGINE-SIZED	The process of sizing paper during its manufacture, as opposed to ATS, which occurs afterwards.
ESPARTO	A species of grass from North Africa and Spain, used in papermaking.
ETCH	In lithography, the application of certain solutions to the background to render it insensitive to the action of grease. The solution itself.
FELT SIDE	The side of paper opposite to the wire side – the side which is uppermost when the pulp is being carried along by the fine wire mesh. In wove papers, the felt side has a more random tooth and is therefore more attractive to printmakers.
GLOSS	The shiny surface of a printed image caused by the build-up of successive layers of ink. A type of ink which dries with a shiny surface.
GRAIN	The quality of texture of the working surface of the stone or plate. The texture which has been applied to it by the process of graining.
GUM-ETCHES	Solutions of gum arabic to which have been added proportions of the appropriate solutions, e.g. nitric acid for stones, Victory etch for plates.
GUMMING OUT	The process of drawing an image in gum or gum-etch before applying the ink, chalk or transfer. The method produces a negative image of light against dark.
GUMMING UP	Coating the plate or stone with a solution of gum arabic after the drawing is complete, or when it becomes necessary at any other stage to protect the background, e.g. after etching or erasing ink.

The infinite range of tones of grey, between black and white. Similarly, the range of tones of a colour between white and the colour in its purest form. HALFTONE

A range of compounds containing only hydrogen and carbon. Used in the preparation of dyes for lake colours. HYDROCARBONS

A compound radical consisting of one atom of oxygen and one of hydrogen. Chemically: OH. A radical is a group of atoms which behaves as one single atom, being unchanged when moving from one compound to another during any chemical reaction. HYDROXYL

Easily absorbing moisture, as gum arabic. HYGROSCOPIC

A mark or series of marks produced by printing. The image area is the over-all space occupied by such marks, the actual printing area of the plate or stone. IMAGE

The assembling of type, blocks or plates so that they print in their allotted position on the finished page. IMPOSITION

A proof. The act of printing. The pressure exercised during printing. IMPRESSION

The bed on a flat-bed offset press which backs up the paper during printing. IMPRESSION BED

A cylinder on the rotary offset press which backs up the paper during the moment of printing. The cylinder which carries the image from the plate to the paper. IMPRESSION CYLINDER

The method of printing in which the image area is recessed into the non-printing area, as in etching and photogravure. INTAGLIO

Thin paper which is placed between proofs to prevent the wet ink from offsetting. INTERLEAVING

A linear drawing showing all the boundaries of the shapes in a design, and also indicating the various colour changes. It is used as a guide in drawing the various colour plates which are printed to make the complete image. KEY DRAWING

The rectilinear pattern on certain antique papers made by the pattern of the wire mesh in the paper-making machine. LAID

Colours which are made by dying an inert powder, fixing it to make it chemically stable and light-fast, and then suspending it in a medium. LAKES

General term for all relief methods of printing. LETTERPRESS

A process in which a photo-engraved metal plate is made from a hand-cut negative of the artist's drawing. The plate is inked in relief and overprinted on the related design. The result is a debossing, manifested as a score line which holds a distinct lip of ink. LINE-CUT

A tough paper which can be used to form some of the backing on the transfer press. MANILLA

MECHANICAL WOOD Wood fibres which have been shredded mechanically for use in papermaking, as opposed to chemical wood which is broken down by strong caustic solutions. Papers containing wood, such as newsprint, become brittle and turn yellow quite quickly.

MEDIUM See Vehicle.

MF PAPER Machine-finished. A cheap paper of moderate weight useful for proving plates and stones.

MG PAPER Machine-glazed. A reasonably cheap paper of moderate weight, rough on one side and smooth on the other, used mainly for posters. Useful in lithography for making offsets and for colour proofing.

OFFSET Abbreviated as O/S. To print on to the receiving surface via an intermediate surface. Term popularly used of a wet proof printing back to the plate containing the next colour, or, when in a pile, on to the back of the print above it.

OVERPRINTING The printing of one colour on top of another, to produce a third. The printing of type over a visual image.

pH VALUE The relative acidity or alkalinity of a substance.

PICKING The removal, during printing, of fibres of paper, or even larger areas, by the ink on the plate. Usually caused by the ink being too tacky for the strength of paper being printed.

PLANOGRAPHY Any method of printing from a flat surface, e.g. lithography.

PLATE BED The bed on the flat-bed offset press to which the plate is fixed.

POLYAUTOGRAPHY Early name for lithography, said to have been coined by F. Johanndt of Offenbach.

POLYMERIZATION The process of oxidation of the vehicle which causes the molecules to join together to form chains, or polymers. These have the same chemical composition as the molecules from which they are formed, but possess proportionately much greater strength and cohesion than do the same number of separate molecules. Dried linseed oil, linseed oil varnishes and synthetic resins used in printing inks come into this category.

PRINTINGS (1) Printing papers, as opposed to 'writings'.
(2) The number of times the proof has been impressed; the number of colours may not always be synonymous with the number of printings.

PROGRESSIVES A series of proofs taken when proofing in colour, to show all the intermediate stages of overprinting before the finished state. In a four-colour print the progressives would be as follows: 1 by itself, 2 over 1, 2 by itself, 3 over 2 over 1, 3 by itself, 4 over 3 over 2 over 1, 4 by itself. If colour changes or changes in the sequence of printing are contemplated, extra progressives can be taken, e.g. 3 over 1, or 2 over 4, etc.

The process of printing the plates in sequence of colour, before making a firm decision about the choice of colours for the final edition.

PROOFING

This general term covers the processes of preparing a stone or plate, after the drawing has been gummed, until the rolled-up image has been etched and gummed.

PROVING

Refraction is the deflection of light as it passes from one medium to another, and the index is a measurement of this deflection. In printed films of colour, the two media would be the vehicle and the pigment.

REFRACTIVE INDEX

A measure of the amount of water in the atmosphere compared with the maximum amount that the atmosphere could contain at the same temperature.

RELATIVE HUMIDITY

See Letterpress.

RELIEF PRINTING

See Counter-etching.

RESENSITIZING

A name given to sub-standard hand-made paper.

RETREE

The unwanted deposits of printing ink or press black on the non-printing area of a litho stone or plate.

SCUMMING

An ink which has lost much of its viscosity. The usual reason for this is the addition of an over-generous amount of magnesium carbonate. This causes the ink to move towards the crumbly consistency of raw, short pastry, incapable of being rolled out into a thin film.

SHORT INK

The effect of an unsized or soft-sized paper on the ink film. It is manifested by a reduction in the bite of a colour. Much of the vehicle is absorbed, causing the ink film to dry with a matt surface. The effect is more marked on dark and luminous colours.

SINKING

This can sometimes refer to the process of gumming out, but is more accurately applied to the process of gumming out over a partially drawn image before adding more drawing.

STAGING OUT

A stick of writing ink or a very soft litho crayon, which is rubbed on to the finger or a piece of rag. These are gently rubbed on to the plate, so that some of the grease is transferred. The technique produces a very fine tint, akin to a wash.

STUMPING INK

The sticky or adhesive property of printing ink, which can be gauged by the length of the threads formed when a roller is lifted clear from the ink film on the slab. The longer the threads are stretched before snapping, the more tacky the ink. It can be modified by the addition of a little linseed oil or a gel reducer.

TACK

A term which was originally applied to painting canvas, but which has now been extended to include paper. It refers to the relative fineness or coarseness of its surface texture,

TOOTH

thus indicating whether it would be suitable for receiving a particular type of image.

TUSCHE The name by which litho writing ink is known in the USA.

VARNISHES These are made from linseed oil or resins, which are partially polymerized or oxidized, and therefore require less time to dry. They are the bases of all printing inks, and are used in their pure form as ink additives in the studio.

VEHICLE (Or medium) General name for the drying oils or gums in which are suspended pigments to form paints or printing inks.

VICTORY ETCH A proprietary brand of tannic acid etch used for zinc and aluminium plates. Care should be exercised when using it in its concentrated state; it should be washed off within a few seconds of application, as it will penetrate the ink and erode the basic adsorbed image. Diluted with gum arabic, it makes an excellent first etch, and if diluted with water in the proportion of one part of water to two of Victory etch, etching can be carried out more leisurely and with a greater safety margin.

VISCOSITY A printing ink's resistance to flow. This is a prime quality in litho printing inks, preventing the ink on the plate image from spreading to the adjacent non-printing areas.

WASTED KEY A key drawing used for preparing a series of colour plates in lithography, which is not used in the print itself.

WATERLEAF PAPERS Unsized hand-made papers.

WEB The continuous sheet of paper which is made on the paper-making machine, and which is collected on large reels at its end.

WEB OFFSET A series of offset rotary presses connected together to form one large unit, capable of printing on to a continuous web of paper. Mostly used for newspaper and magazine work.

WET AND DRY Waterproof abrasive paper which can be used wet or dry. The finer grades have several uses in the studio.

WIRE SIDE The bottom side of the paper web which rests on the wire mesh belt that carries it along the papermaking machine. It is characterized by a fine, even texture.

WOOD-FREE Machine-made paper of good quality which contains no wood.

WRITING INK The greasy ink used for drawing on plates and stones. It can be obtained as a stick, to be mixed with water or white spirit, or as a ready-prepared liquid.

Appendix I : safety in the studio

In a lithographic studio, injury to persons working can occur in several different ways, and it is best, if prevention is impossible, to arrange matters so that any harm is minimal. Accidents can occur, not so frequently in the artist's own studio, but when artists or students use facilities on a communal basis and on different occasions.

The dangers can arise from fire, physical damage from presses or other potentially dangerous implements, or through inadequate storage or labelling of the various chemicals. For example, it is tempting when diluting acid or caustic while in the middle of some vital plate work to put it into an unlabelled bottle or, even worse, a bottle with an unrelated label on it.

Many of the substances used in printmaking are highly inflammable. These include paper, printing ink and washout solution, as well as volatile solvents such as white spirit, paraffin, petrol, and methylated spirits. There is usually need for a naked flame for the mixing of writing ink. If gas is laid on, then a bunsen burner is best, but the normal method is to use a spirit lamp or a candle standing in a saucer. The disposition of these items should be such that they can never be placed near to inflammable solutions. It is better to store the bulk quantities of solvents in a locked cupboard at floor height, and to fill the various sprinklers and jars away from any naked flame.

Fire extinguishers should be of the foam type, as burning spirit will float on the surface of water and spread the fire. It is advisable to ask the local fire service to advise upon, instal and maintain the fire equipment.

Injury can be inflicted in several ways from the presses, and these dangers should be pointed out to each new student as he joins the class. The most common injury occurs when rolling up a plate or stone from the front of the transfer press, without first making sure that the tympan stay is in position The tympan falls on the operator's head, and the resulting injury is in proportion to the size of the tympan. Other dangers from presses include fingers trapped in the runners, and sometimes between the rack and the cylinder gear wheel on the offset press. It is essential that damping buckets be kept well under the presses: tripping over them can trigger off an unpleasant sequence of events.

These accidents become more serious if the presses are mechanically or electrically operated, owing to the shorter time factor involved. All motorized presses must have adequate guards over the moving parts, particularly over the belts and pulleys, and over the gears on a transfer press. The various stops on the presses should frequently be inspected for deterioration. If there are a number of electrically operated presses in the studio, there should be an emergency stop switch easily accessible to override all the other switches, which when punched, will immediately cut out every press that is being used.

Care should be taken when using the levigator that it is being turned in the proper way to avoid the disc from becoming unscrewed from the handle.

All chemicals in bulk should be kept in a locked cupboard and clearly labelled. When diluting them to their working strengths, the method described in the text should be adopted. Nitric acid reacts very dramatically when spilt on certain materials and metals. On no account should the brown gas which results be inhaled. Also, splashing can occur. Burns on the body should be treated initially with plenty of water to dilute the acid to a harmless concentration. Small burns caused by pinpoints of acid might pass unnoticed for a few minutes, but a sudden stabbing will indicate that the acid has penetrated to a nerve. Caustic burns are dealt with similarly, although their action is rather more insidious. Water is the best initial treatment.

For injuries and burns of a more serious nature, professional treatment and advice should be sought without delay.

Appendix 2: ancillary equipment

Bridge or barrel stave for drawing stones
Buckets for damping, etching and cleaning (should not be interchanged)
Cellulose sponges for damping and cleaning (should not be interchanged)
Small sponges for applying etches (should not be interchanged)
Craft knife or Stanley knife
Damping book
Drawing instruments
Electric fan or heater
Flag fan
Funnels for decanting turps and solutions
Glass fibre brushes
Graduated measure for mixing solutions
Household paintbrush
Ink slabs
Jars or containers for gum, gum/etches and other solutions
Levigator
Linen prover
Litho pens and nibs
Oil cans
Palette knives
Push knives
Rags
Registration needles
Rollers (nap, glazed and rubber)
Sable brushes, various sizes
Scissors
Set of tools for press maintenance (spanners, screwdrivers etc.)
Sieves for graining
Small hand rollers for taking transfers
Stone files, rasps etc.
Straightedge
Surform plane and an ordinary plane
T-square
Tools for various purposes around the studio: woodsaw, hacksaw, pincers, pliers, hammer, hand drill etc.
Turps sprinkler
Type scale for bookwork
Vices: preferably both a metalwork and a woodwork vice, but if a choice has to be made, the metalwork vice is more versatile, as its jaws can be lined with wood when holding a soft material.

Appendix 3: materials and solutions

ACIDS: BASIC SOLUTIONS FOR MIXING OR DILUTING

Nitric acid: etch for stones
Tannic acid: etch for aluminium and zinc plates, also marketed as 'Victory Etch'
Atzol: gum/etch for aluminium and zinc plates. A mixture of gall-nut decoction and gum arabic
Carbolic acid for erasing work on stones
Sulphuric acid for erasing work on aluminium plates
Caustic potash for erasing work on zinc plates
Acetic acid and citric acid for resensitizing stones
Nitric acid/potash alum for resensitizing zinc plates
Fluorsilicic acid for resensitizing aluminium.

OTHER SOLUTIONS

Washout solution
C1175 white washout solution for use before colour printing
Turps substitute or white spirit
Paraffin
Petrol
Methylated spirit

POWDERS AND DRY INGREDIENTS

Gum arabic, in lump and powder forms
Resin: acid resist for the image
French chalk: acid resist for the image
Light magnesium carbonate: additive for printing inks and for gloss prevention
Violet offset powder. This is very scarce: recommended substitutes are powdered red ochre, jewellers' rouge and pottery pigments

MATERIALS FOR STONE PREPARATION

Coarse grinding sand
Sand of various grades for graining
Pumice powder for graining
Pumice block
Snakestone block and slips
Other abrasives as dictated by personal choice

MATERIALS FOR IMAGE-MAKING

Litho writing ink (stick or liquid)
Litho chalks or crayons, various grades from 00 to 5
Distilled water

Appendix 4: recommended papers for printing

HAND AND MOULD-MADE PAPERS

Rives BFK from Rives Mill, Rives, Isère, France. Mould-made. Weight varies from about 180 gsm to 250 gsm. Half-sized.

Arches from Arches Mill, Arches, Vosges, France. Mould-made. Weight about 250 gsm. Half-sized.

English Etching Paper from J. Barcham Green, Hayle Mill, Maidstone, Kent, England. Hand-made and hot-pressed. Weight about 300 gsm.

Crisbrook from the same supplier. Hand-made and hot-pressed. Imperial size: 140 lb. About 300 gsm. Both of these papers are waterleaf.

JAPANESE PAPERS

Hodomura white and tinted, unsized.

Hosho white, unsized with very light laid marks. Both of these papers are obtainable in various weights. Other Japanese papers, eg. *Bugegawa* and *Tatsumaki*, have large fibres in their make-up. These can range from a silky white, through straw to brown. In some cases, they are raised so much from the surface that good ink transfer is problematical. However, some of them have been used very successfully in colour lithography. Japanese papers can be obtained from Messrs T. N. Lawrence and Son (see Appendix 5)

MACHINE-MADE PAPERS

Snocene Cartridge from Thomas Tait of Inverurie, Wheatsheaf House, Carmelite Street, London EC4. Available in various sizes and weights up to 170 gsm. Sized. Neutral pH.

PAPERS supplied by Grosvenor Chater & Co. Ltd (see Appendix 5)

Royal Cornwall Cover. Available in weights 163 gsm. and 265 gsm.; made in various colours including white.

Design Cover. Weight 142 gsm. Available in various colours including white.

Ivorex Boards. Hi-white or Super white matt. Available in weights 190 gsm., 224 gsm. and 300 gsm.

MG paper for proofing. Weight 63.5 gsm.

Mechanical SC printing for proofing. Weight 71 gsm.

PAPERS supplied by G. F. Smith & Son Ltd (see Appendix 5)

White Tranby Antique. Weight 273 gsm. and 310 gsm.

Caslon Bright White. Weight 270 gsm.

Appendix 5: suppliers of materials

	Lithographic sundries	Hand-made paper	Machine-made paper	Zinc and aluminium plates	Presses	Printing Inks	Rollers	Scrapers	Stones	White washout solution
UK:										
Ault & Wiborg Ltd, Standen Road, London SW18 5TJ						●	●			
Barcham Green & Co., Hayle Mill, Maidstone, Kent ME15 6XQ		●								
L. Cornelissen & Son, 22 Great Queen Street, London WC2B 5BH	●			●		●	●	●	●	
The Forrest Printing Ink Co., 48 Gray's Inn Road, London WC1X 8LX						●				
Grosvenor Chater & Co. Ltd, Laycock Street, London N1 1SW			●							
Frank Horsell & Co. Ltd, Howley Park Estate, Morley, Leeds LS27 0QT						●				●
Hunter-Penrose-Littlejohn, 7 Spa Road, London SE16 3QS	●			●			●			
T. N. Lawrence & Son Ltd, Bleeding Heart Yard, Greville Street, London EC1 8SL		●								
G. F. Smith & Son Ltd, Lockwood Street, Hull HU2 0HL			●							
USA:										
Apex Printers Rollers Co., 1541 North 16th Street, St Louis 63106, Missouri							●			
Charles Brand Machinery Inc., 84 East 10th Street, New York 10003, NY					●			●		
Crestwood Paper Co. Inc., 263 Ninth Avenue, New York 10001, NY			●							
Graphic Chemical and Ink Co., P.O. Box 27, 728 North Yale Avenue, Villa Park 60181, Illinois				●	●	●	●	●	●	
William Korn Inc., 260 West Street, New York 10013, NY	●									
Rembrandt Graphic Arts Co. Inc., Stockton, New Jersey 08559	●	●	●	●	●	●	●	●	●	

Index

Page numbers in italics refer to illustrations